VINCENT VAN GOGH

VINCENT VAN GOGH

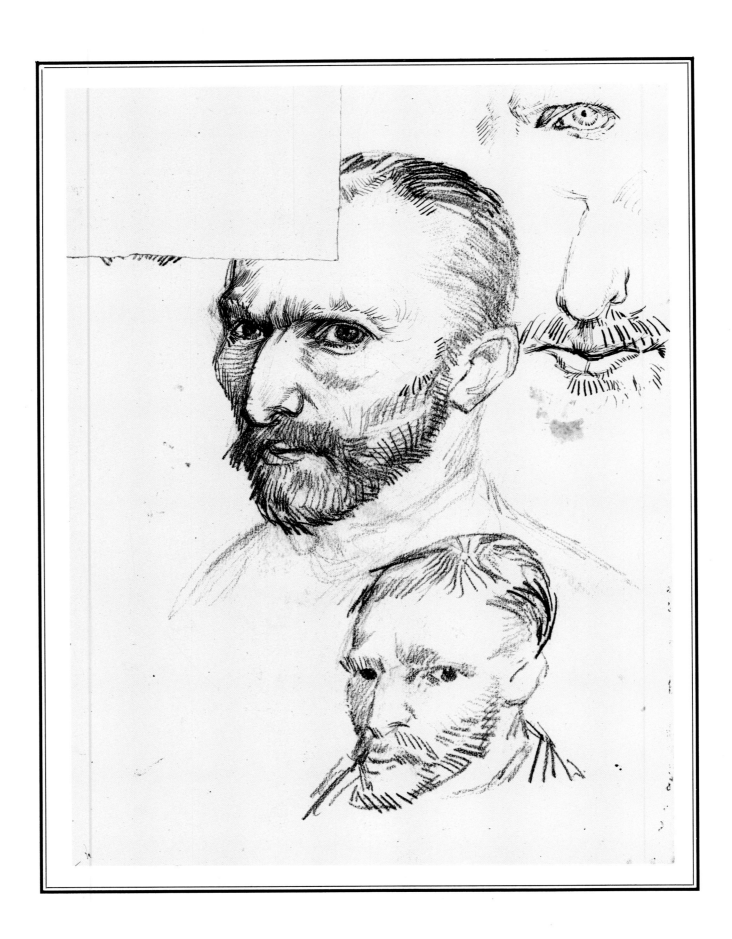

PER AMANN

VINCENT VAN GOGH

PADRE PUBLISHERS

Translated by Jennifer Barnes

PADRE PUBLISHERS

© 1987 by Berghaus Verlag D-8347 Kirchdorf-Inn, Germany
English Language Rights, Padre Publishers
8195 Ronson Road, San Diego, CA 92111 U.S.A.
Fax (619) 277-5790

Printed in the U.S.A.

ISBN 1-57133-372-X

CONTENTS

The first generation of our century discovered van Gogh; the second was powerfully affected by the vast scope of his work and by the tragic background to his life. It may safely be predicted that the lives of succeeding generations will be similarly affected by van Gogh's painting; he loved the sun and exalted it in his pictures, and they seem to reflect a devotion to nature which is on the ascendant today.

Hans Feddersen

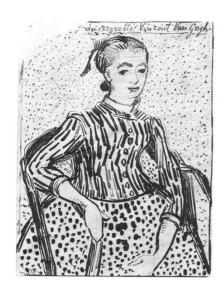

On 30th March 1853, in Groot Zundert, a village in Brabant, a son was born to the young pastor, Theodorus van Gogh, and to his wife Anna Cornelia, and was christened Vincent.

The van Gogh family played a not inconsiderable role in Dutch history; its members were still occupying important posts in government, trade, and the church in the mid-19th century. As a simple pastor, Vincent's father cut a modest figure in this family of administrators, but was highly regarded. His mother was a cheerful, gifted woman, who nurtured family harmony with sympathy and understanding; over the years Vincent acquired three sisters and two brothers. Theo, his junior by four years, was to play a particularly important role throughout Vincent's life: the correspondence between the two brothers charts for us today the struggle that marked every stage of the painter's development. Equally supportive was his mother, who remained in the background, quietly open-hearted to the troublesome eldest son she was to survive.

To begin with, Vincent was launched on a respectable career as an art dealer in the house of Goupil, under the wing of his wealthy uncle and godfather. It was of lasting importance to him to have been involved with so many pictures, looking, comparing and so training his eye. He was particularly taken with the painters of the French school — the works of Corot and of Millet had a decisive influence on his subsequent creativity.

When he was twenty, van Gogh was torn from the cosy introspection of these surroundings and moved to the London branch of the Goupil gallery. There he also encountered his first unhappy love-affair, an experience that proved shattering for the sensitive young man. Seven years later he confessed: "So I fell; and it was a miracle that I recovered. What restored me to normality was, more than anything else, reading scholarly books about physical and moral disorders. I learnt to look deeper into my own heart and the hearts of others. Gradually, I began to grow fond of people, myself included, and as time went by I regained heart and spirit, so long dead in me, withered and ruined as it were by manifold pain and suffering."

He withdrew into himself and even became estranged from his friends. In an effort to help, he was moved to the Paris branch of Goupil, in the hope that the lively artistic life there would distract him from his sorrows. Even that availed nothing; van Gogh set up in a house in Montmartre, surrounded himself with reproductions of his favourite painters and dedicated himself in private to the written word with the same intensity as he devoted professionally to the furtherance of his career in the world of art. During these years as an art dealer, he acquired a wide-ranging knowledge of the whole extent of contemporary artistic activity. His profoundly religious approach, doubtless inherited from his parents' home, meant that he fathomed more clearly the truthfulness in all experience, particularly in what he saw and read. This brought him into conflict with himself, for his feeling for paintings finally became so intense that he could no longer bring himself to deal in them. For him, art and trade became irreconcilable. It seemed to him that to connect paintings with money was a betrayal of the soul of the painter, who had put his inmost being into them. He refused to remain a dealer; he was forced to see himself as a servant of truth and so to give back all the salary he had earned through paintings and books. A painful schism between himself and his planned career was inevitable; from April 1st 1876 Vincent was dismissed from the profession he had learnt and so from the prospect of an assured bourgeois existence. He wrote to Theo: "If the apple is ripe, the gentlest breeze will blow it from the tree."

During this period of self-absorption in Paris, van Gogh had made an unusually thorough study of the Bible. The pattern of piety from the parental home was so deeply etched that he was now overtaken by a burning desire to be a missionary. He had encountered the social deprivations of the working class when he was in London, and he now believed that it was there that his duty lay. At first, he accepted an unpaid position as assistant teacher in Ramsgate, but disenchantment soon set in and he became assistant preacher to a minister, who was also his friend. Yet this too was doomed to failure; he realised that he did not yet have the basic qualifications that the job demanded. He returned to his parents' house, where genuine efforts were made to advise him. After many compromises, and with the help of his large and influential family, it was arranged that he should study theology at Amsterdam. He was far behind in the realm of abstract knowledge, but was inexorably determined to catch up, while at the same time being entirely conscious of the full force of his family's expectations, relentlessly urging him on to ever greater achievements. He wanted to complete his state examinations in the shortest possible time, and remorselessly overtaxed body and brain: "My head is sometimes numb, and often burning, and my thoughts confused – I simply do not know how I can complete such demanding and detailed studies ... and yet I keep at it." The result was a physical breakdown, which put an end to his work and caused a far-reaching rift with his relations, who could only see in this further proof that he was an ineffectual failure.

Back at home, he took heart again. He returned to the idea of the missionary school that had inspired his visit to England, and accepted a posting from the Evangelising Committee to Belgium, to the poorest of the exploited, the coal-miners in the

Borinage district. He lived in Paturages near Mons. Faced with the unspeakable poverty of these workers, he soon realised that it was not just fine words that were lacking here; the church itself had opted out, but Vincent, idealistic to the last, hurled himself at the problem and did all that he could to alleviate their privation without incurring social disfavour. He felt that he was closely linked to these people, renouncing personal possessions and living with them and like them as friend and support. And he was constantly bedevilled by the question: What was the church of Christ as a whole doing to remedy such misery? Himself in the ranks of the poor, he was unaffected by the prevalent complacency; seeing the sharp sword of social hatred that transfixed the fundamentally kindly hearts of the workers, he had to allow that right was on their side. He wrote to Theo: "It is best to keep silence, for the citizens do not have fate to back them, and we have more to live through, the end is still far off." He foresaw the tumult of the subsequent workers' revolts in the Borinage, but was powerless to intervene, alone against so much injustice.

Of course this attitude to the powers that be could not remain concealed, and the next blow fate struck him was not slow in coming. In the autumn of 1879 he was suspended and stripped of the right to continue his activities among the miners in the name of the mission. In the eyes of his family at large, he had failed yet again, and even his parents' faith in him was profoundly shaken — he was isolated and alone.

A terrible year ensued. Homeless and penniless, he roamed around, eventually returning to the Borinage area. He was depressed and deeply disturbed. He, who had always opened his heart to the sufferings of others, was now almost overwhelmed by his own. The emotional bond with his brother was under strain, for even he could no longer summon up the understanding Vincent needed. In their letters, the brothers had always confided their thoughts and emotional reactions to each other, and now he found himself thrown back entirely on his own resources. Only rarely from now on did he venture to write, but write he did: this was one outlet for his affliction that he could not abandon.

Henceforward, his letters reflect not only his own feelings but also external impressions. Since childhood, an unusually dark sky, a building that looked abstract, or a mood of lightness had aroused figurative reactions in him. In his letters, he translated such feelings into words, he described them for others; for himself, he expressed them through his drawings. So the pencil became his trusted companion even in that dreadful year; later it was to become his rising hope. From the very depths of his loneliness he recognised the budding of this hope and immediately wrote to tell his brother of it: "And yet even in such suffering, I felt that my energy was returning and I told myself: However it may be, I will rise again, I will take up my pencil that I laid down in my time of greatest despair, and I will devote myself to drawing; and since then everything seems to have changed for me, and now I am underway, and my pencil has become a little more tractable, and day by day things are improving. My pain, too great and too prolonged for me, had disheartened me so much that I was incapable of work."

The shipwreck of his missionary plans, the severe winter, and his loneliness could not subjugate Vincent van Gogh; he was conscious of a new life-force: "Now my real

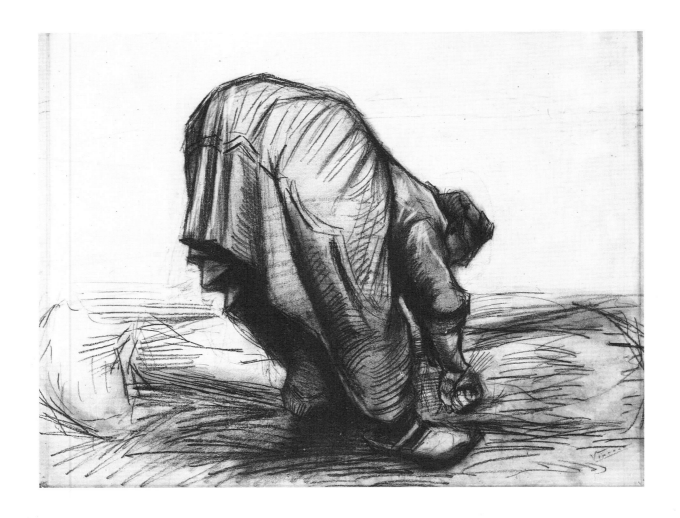

self is developing." But the way ahead was laborious, for he had no innate gift for draughtmanship, and he had to achieve it by sheer hard work. So he pressed ahead unremittingly with his drawings of the mountain people, which taught him the use of proportion and perspective, light and movement. The results did not satisfy him, for his line-drawing was clumsy, as he well knew; however, he had an inner conviction that he would succeed in overcoming this handicap. In October 1880 he left the Borinage to look for contacts with painters in Brussels. Almost at once, he struck up a friendship with the well-placed young painter Anton Ridder van Rappard. He allowed Vincent to use his own studio, where, tirelessly, he learnt, sketched , and learnt again. Things were looking up. He had renewed contact with his brother and resumed relations with his parents, and both of these moves were vitally important to him, not only because of the small allowance that both provided. Once again, he could return home and work there. He turned down a place at an academy in order to be able to continue his studies in congenial surroundings. He drew willows, peasants working, digging, and ploughing; he tried to capture not only the form but also the gruelling nature of the work, the full extent of reality. And there was a visible improvement: his subjects were imbued with greater vitality. When — seven years after his first unhappy affair in London — he fell in love again, it marked the rebirth of "... a great, secret, hidden strength". This strength flooded straight into his

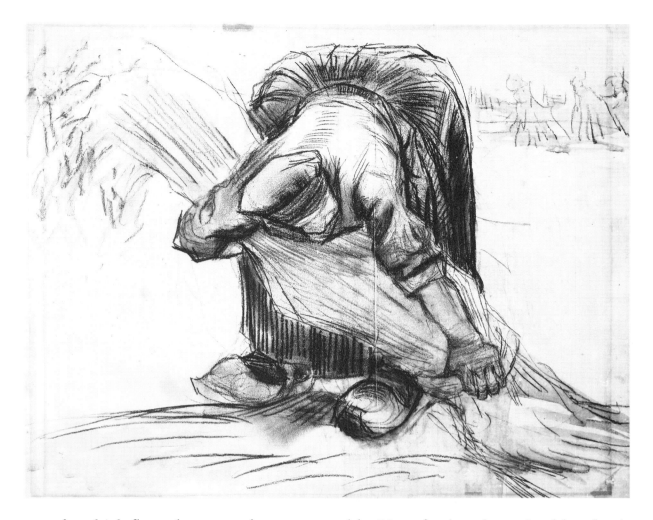

work, which flowed more and more smoothly. Yet a further shattering blow lay in store for him — he was rejected once again. This time he would not accept her decision: he struggled, he importuned, he pleaded, and thought he was gaining approval, not realising to what extent he was destroying all that had so recently strengthened him. His parents and the girl's — also pastors — intervened with tactless and intrusive accusations. Mutual recriminations and disagreements wore him down and culminated in a general family row; the newly-healed wounds of misunderstanding reopened — but this time it was more serious. His father no longer seemed to him the man he had once so revered, now that his bitter reproaches had soured any hope of an enduring love. "Father cannot live in sympathy with me, and I cannot adapt to his routine; it is too constricting, I would suffocate. If I tell Father something, it's just meaningless babble to him, and that's how I feel about his sermons and his stupid ideas about God, man, morality, and virtue. I do read the Bible ... but in the Bible I see quite other things than he does, and what he reads into it with his petty academic precepts I simply cannot find at all." His inner constancy was once again to be van Gogh's downfall: the prodigal son, just returned, was once again ejected from the parental home, this time in anger. For him, this marked his final break with the conventional church — but his Christian belief was stronger than ever.

"You see, for me he is stone dead, this god of the priests. But does that make me an atheist? The pastors think so — alright then — but look at me: I love, and how could I feel love, if I myself were not alive, and if others weren't alive? — and if we are alive, that is a wonderful thing. Call it God or human nature or what you will, but there is a certain something that I can't define and that, although it is uncommonly alive and real, seems to me to be some sort of system; and you see, that is now my God, or as good as my God."

Vincent went to The Hague, in search of guidance from his cousin Mauve. But the latter's academic ideas were bound to clash with Vincent's; he had seen so much of life and was bursting to express it, and yet in his cousin's eyes, he had accomplished nothing. They quarrelled. Van Gogh then attempted to sell some of his drawings, with the help of his former teacher Tersteeg. Here, too, however, he encountered only disapproval and the familiar accusation "You can do nothing and are worth nothing!" Once again, he was overwhelmed by discouragement and despair.

And as fate had till now made a habit of dealing him a shattering blow just as he was finding his feet, and of sending him a ray of hope to illuminate the darkest abyss, so it happened now. In a cold winter's street he happened across a wandering prostitute; disease and suffering had etched deep lines into her face and she was, moreover, pregnant. Deeply affected by her incomprehensible suffering, forgetful of his own privations, he took the poor creature home with him. He sacrificed everything in the effort to restore her to humanity once more, shared with her his accommodation and the tiny income that his brother allowed him, and lived for nothing but his new task. Christine, or Sien, as he called her, was part of his destiny: "... She was alone and abandoned like a cast-off rag, and I raised her up, and devoted to her all the love, all the tenderness, all the care that I had in me." In his eyes, it went without saying that one should love one's neighbour in the most literal sense. And when Sien recovered, he was rewarded with immeasurable joy. The birth of her child filled him with emotion and happiness, and what had begun as solicitude deepened into the special human relationship that he had yearned for for years. "It is strange", he wrote, "how pure she is, in spite of her depravity, as though something quite different had survived in the ruins of her soul, her heart, and her spirit." Another time he confessed to Theo: "But gradually something new grew up between her and me, an unmistakable need for each other, so that we, she and I, could not leave each other, and as time went on entered ever more deeply into each other's lives, and then it was love. What exists between Sien and me is real, it is not a dream, it is reality."

Vincent van Gogh never found any kind of ugliness repulsive. It was precisely to the pitiable that he gave himself most freely. From the profound charity of his nature flowed a constant stream of understanding for others, even if it met with little sympathy in return. Among the hardships of life he succeeded in finding more than bitterness. Thus, he liked to draw in the poor-house; even when he could have afforded other models, he chose not to. He wanted to restore the esteem of outcasts, of lost souls. Rubbish dumps, rag-pickers, the broken, the rejected: nothing was worthy his neglect. These studies trained more than his draughtsmanship: "Because

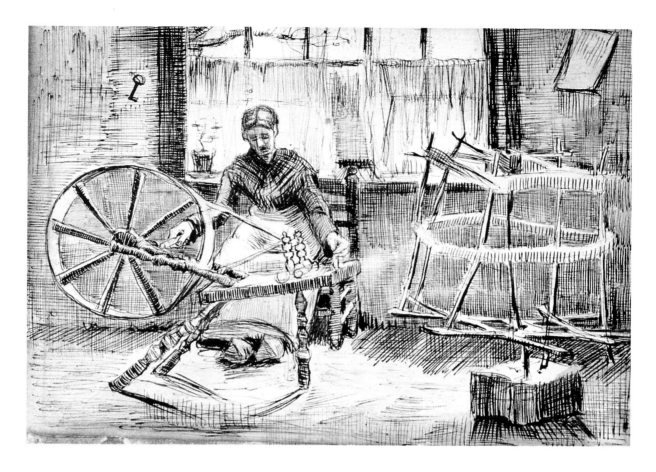

I see so many weak souls trampled underfoot, I am reluctant to believe in the truth of much that is called progress and education. I do believe in education, but only in the kind that is based on a genuine love of mankind."

It was a period of maturition, and the child helped this process: "How good it is for a man to walk on the shore when he is downcast, and to gaze at the grey-green sea with the white breakers. If you yearn for something great and infinite, something in which you can see God, you do not need to look so far; it seems to me that I saw something – deeper – more infinite – more eternal than the ocean in the expression in the eyes of a little child ..." Sien had given him strength and was inspiring him to ever greater expressive heights.

In the following months van Gogh began to paint. Till then, he had only drawn, satisfying his artistic urge with the forms of men and objects, but now he began to be aware of colour. "... Now, since I bought brushes and paints, I have been working, nay slaving, away till I am dog-tired ..." "... I feel that when I paint things appear to me in colour which I never saw before. Things full of breadth and strength ..."

In the Christmas of 1883 he moved to his parents' house, now in the living of Nuenen. As ever, father and son were divided by the impenetrable wall of misunderstanding, but they lived under one roof for two decisive years. Vincent no longer had to worry about where the next meal would come from, and was free to concentrate totally on his painting. He got to know the weavers, poor men

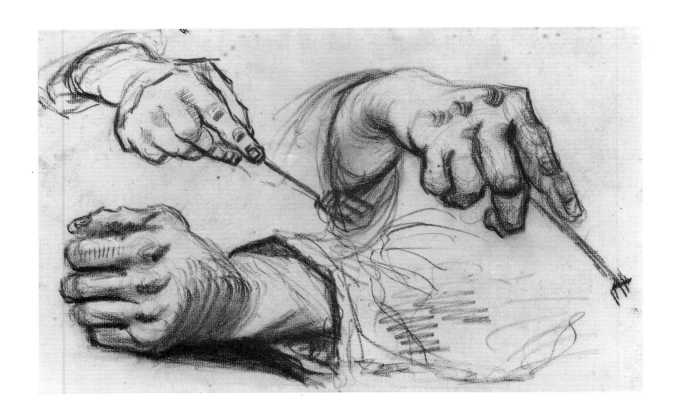

overworked by day and by night with no prospect of escape from ever-encroaching poverty. He painted them in their surroundings, trying to portray above all the grim fate that they could not evade. Those who beheld these pictures were to feel it too.

Once again, van Gogh tried to adapt himself to a regular routine by registering at the Academy at Antwerp. His personality, or rather his appearance in the simplest of peasant dress, had a distinctly dampening effect on his professors' enthusiasm. There was little mutual sympathy. Vincent was not prepared to accept elementary teaching materials such as plaster figures, and the teaching authorities found they could not recognise the value of what their pupil felt he could do well. Another débâcle. Van Gogh preferred to learn from nature, however cold it was.

In 1886 he returned to Paris in search of contacts with important contemporary painters. In the quiet years in Holland his feeling for colour had blossomed, and now his encounters with the Impressionists provided an outward incentive: his whole palette of flaming colours burst into life. The few years in Paris saw a plethora of glowing, joyous paintings, of ships and rivers, bridges and gardens, and many pictures of flowers. He had overcome the leaden earthiness of his northern home, and there were as yet no signs of the tragic outcome of the later years in the south and in Auvers. But Vincent felt that, in Paris, he was slowly being consumed, burnt out. True, his painting friends were exciting company and a continual source of new artistic perceptions. But the hectic life he led, fuelled by alcohol and cigarettes, was sapping his strength. So it was that his longing for the sun, for the glowing light that perfected Cézanne's works, the fire in the soul of the searcher, drove van Gogh out

of the city and down south. He moved to Provence, and in Arles he found accommodation and the landscape that his artist's eye craved. He revelled in colour; and yet became ever more conscious that this total absorption in his work was overstraining his exhausted body, that his physical resources were waning rapidly, and that his bursts of creative activity tended more and more to culminate in ill-defined prostration.

Van Gogh's dream of living and working in a house with like-minded painters prompted him to invite Gauguin to Arles. And he came, a successful man with imperturbable self-confidence. In his egoism and his inability to relate to or sympathise with lower forms of creation, he was the absolute opposite of van Gogh as far as personality was concerned. The latter made every last sacrifice for his friend, as he saw him, and offered up boundless adulation on the altar of their friendship. Although Vincent learnt a great deal from Gauguin, they remained at odds about fundamentals. Van Gogh loved the complementary colours, while Gauguin could never accept them as sole elements in a painting. Their differences became more and more marked; tense discussions gave vent to arrogance and self-effacement, and the end result of the friction between them was a serious nervous breakdown for Vincent. Gauguin felt threatened and returned to Paris. In a moment of deep agitation, van Gogh, left alone, cut off a piece of his ear and was discovered unconscious. As a result of his shattered health, he was forced to seek shelter in the asylum for nervous diseases at St. Rémy. It was there that he produced, after some time, the tragically aware pieces of the latter years: cornfields of an over-ripe gold, blue skies, cypresses, and portrayals of people perfect in their delineation of character.

Van Gogh knew about his nervous condition and he kept a sharp eye upon himself: "... As for my health, it's good, pretty well anyway, not so bad. I am happier with my work here than I would be outside. If I stay here long enough, I shall acquire settled habits, and eventually my life will become better-ordered and I shall be less impressionable. And that would be such a big step forward. Besides, I wouldn't have the courage to start again outside this place. Just once I went into the village, and that was accompanied. The mere sight of people and objects made me feel somehow faint and ill. Where nature is concerned, it is the feeling for work that sustains me. But briefly, what I mean is that there must have been an overwhelming agitation inside me that affected me in this way, and I simply don't know what caused it."

Painting was a vital part of Vincent's life. He could do without anything else but that, because for him, painting meant rebuilding his powers: "... Moreover, let us hope that if I recover to any extent, be it sooner or later, it will be because my work has healed me, work that strengthens the will and so prevents spiritual frailties from getting the upper hand ..."

Life in an institution was subsequently to weigh heavy upon van Gogh. Whenever his nerves permitted it, he was, it is true, allowed out into the surrounding country, and was therefore in no way confined; but the state of the other patients, the repellent exterior of the building, the primitive living conditions depressed him. "... Strange that I had been working away at pictures you will soon see, in complete

peace of mind, and that I was suddenly gripped by madness, without any reason ..." "... For it is, I believe, a dangerous thing to pack all these madmen together into this old monastery; one stands to lose all sound judgement that one might have preserved" "... As far as I am concerned, don't worry too much. I defend myself calmly against my illness, and I believe that before long I shall be able to return to work again ..."

When a trusted doctor, Dr. Gachet, suggested he should move to Auvers, he agreed. But he only worked there another few weeks, on pictures of an increasing isolation. In the last painting, black crows are flying across a storm-tossed field. As ever, he conversed with his brother through letters; he wrote and enquired about everyday events or important questions, just as the mood took him, reported his depressions and then tried to reassure his brother. "... It's absolutely true that in the past year, the crisis has recurred at variable intervals — but then it always used to be by working that I would return to normal. I expect that is how it will be this time. So pretend there's nothing wrong, for we can't do a thing about it ..."

But the fear of ever more frequent set-backs was always present. On the evening of July 27th, 1890, Vincent, deranged by yet another attack, tried to shoot himself with a revolver. Dr. Gachet summoned Theo. Vincent himself had written to him on July 27th and given a perfectly lucid account of what he meant to him: "... I tell you again, I shall always take the view that you are more than a mere dealer in Corots, that through me you have been the intermediary for the genesis of certain paintings, have actually participated in them — paintings that preserve their tranquility even in collapse." Theo responded at once to the summons, and so it was that Vincent had his beloved brother with him when, on July 29th, he finally succumbed to his injuries. To the last, he remained fully conscious.

ILLUSTRATIONS

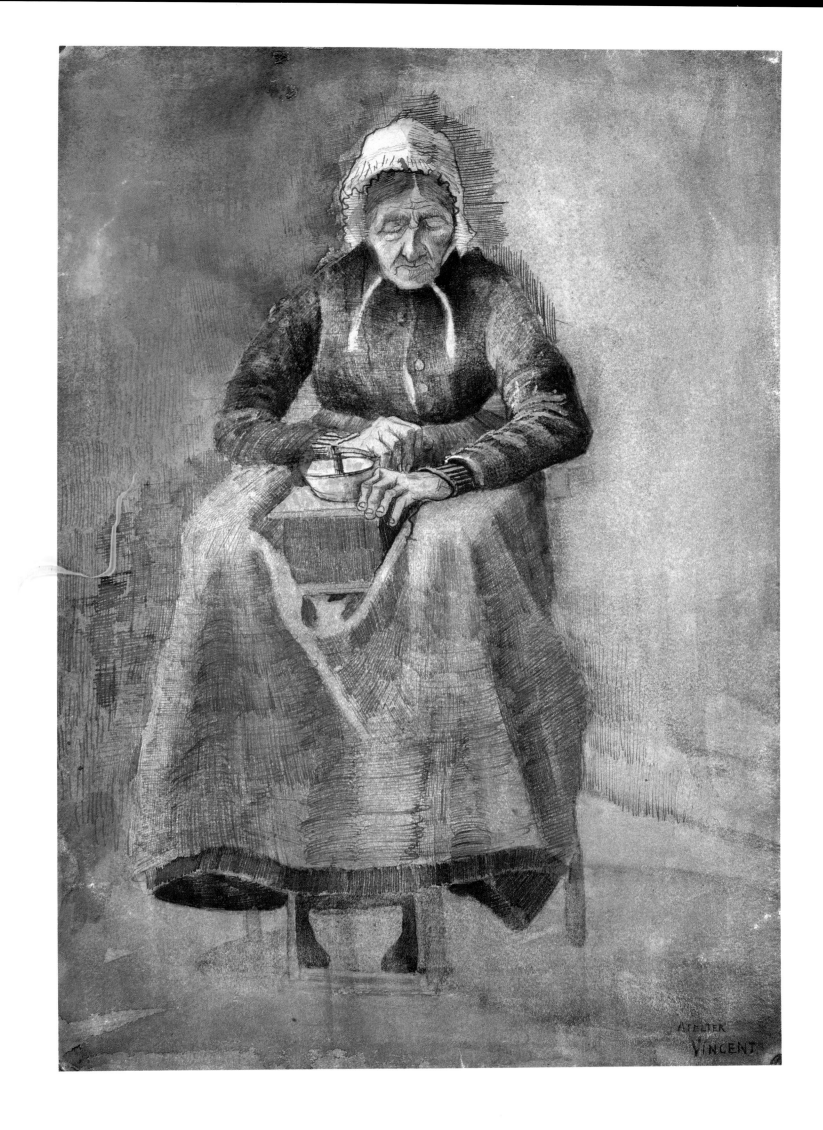

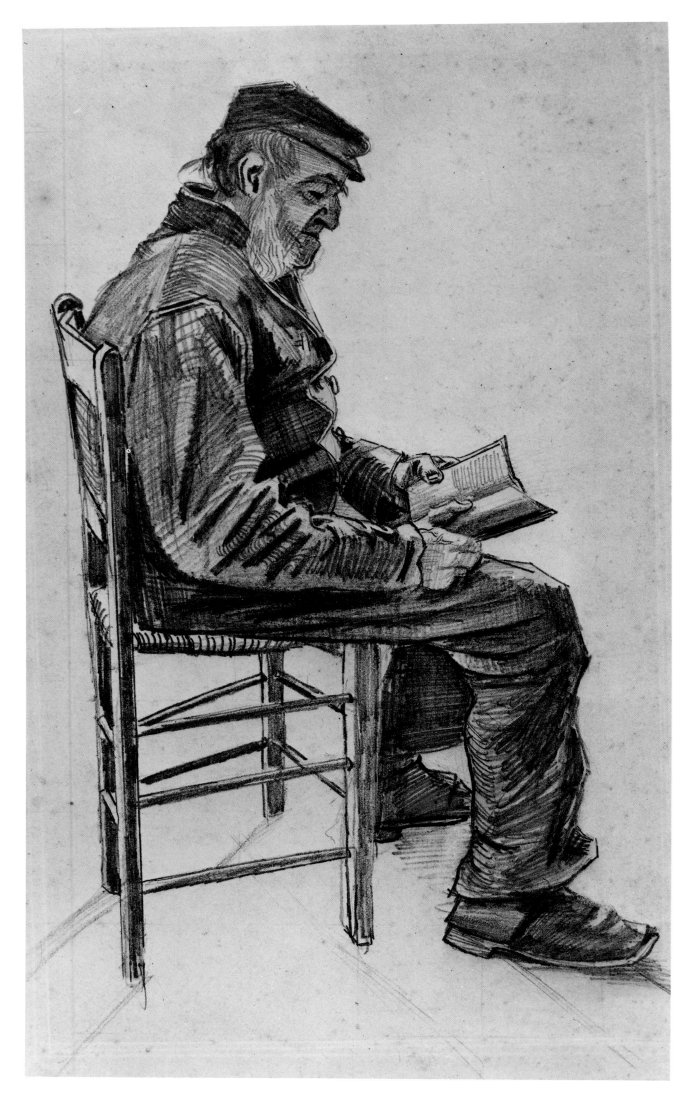

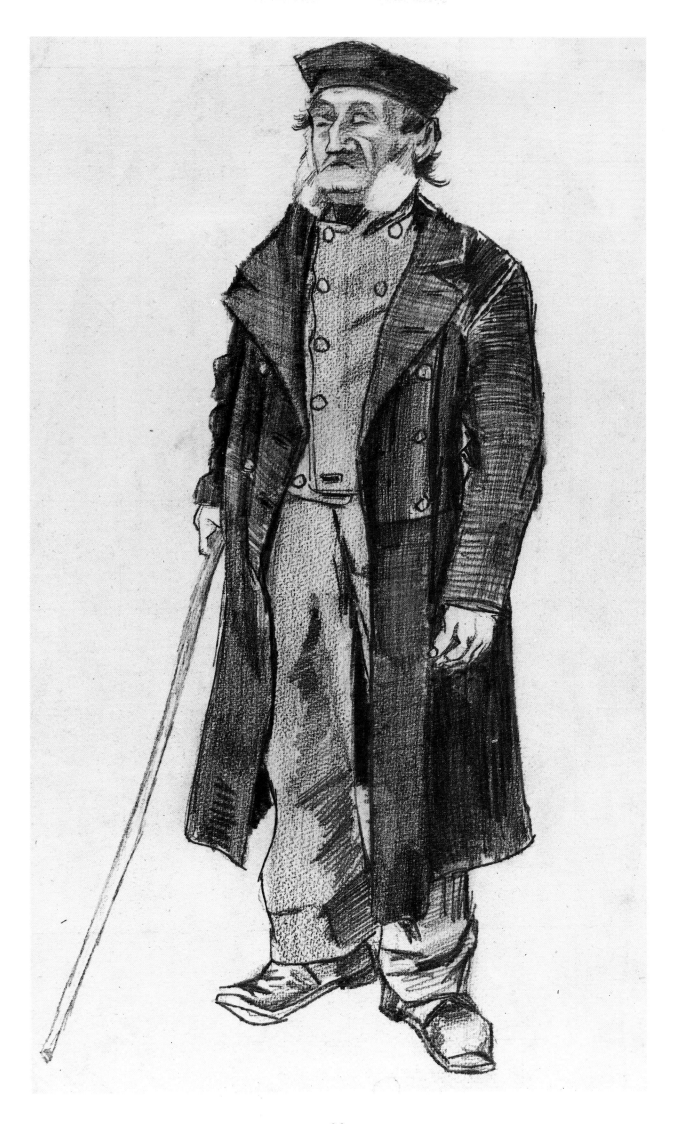

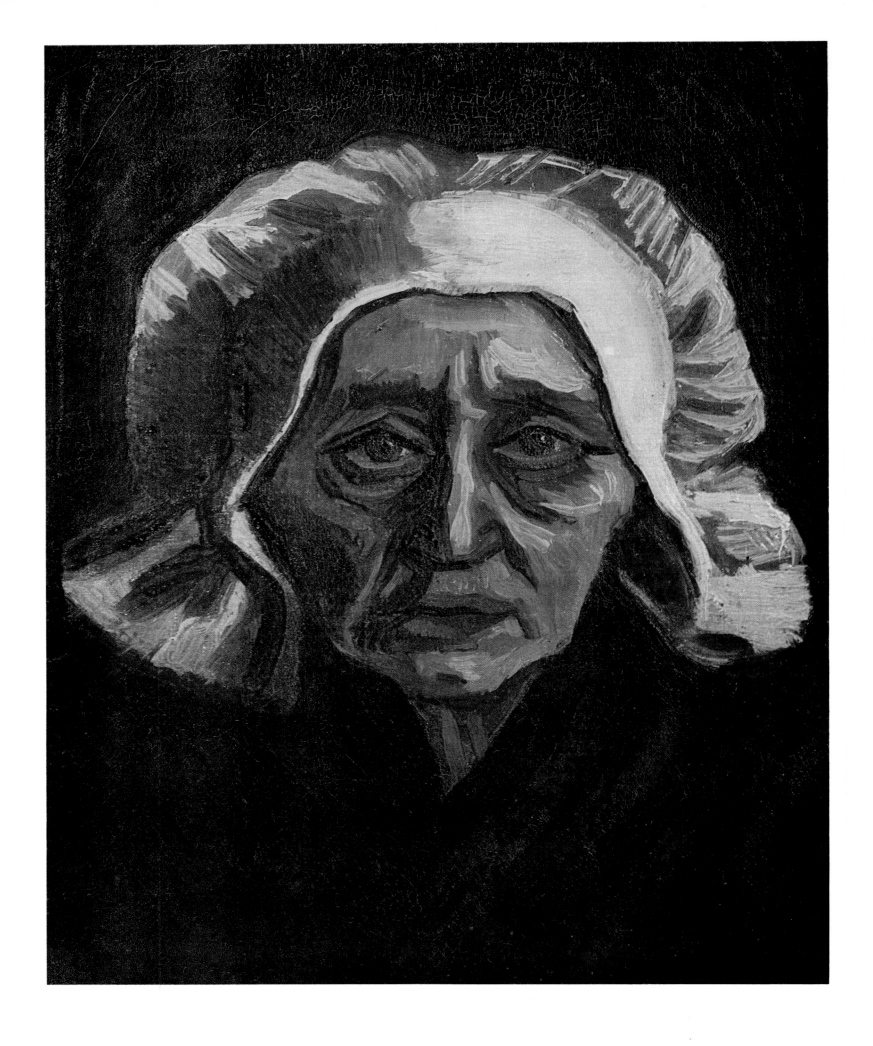

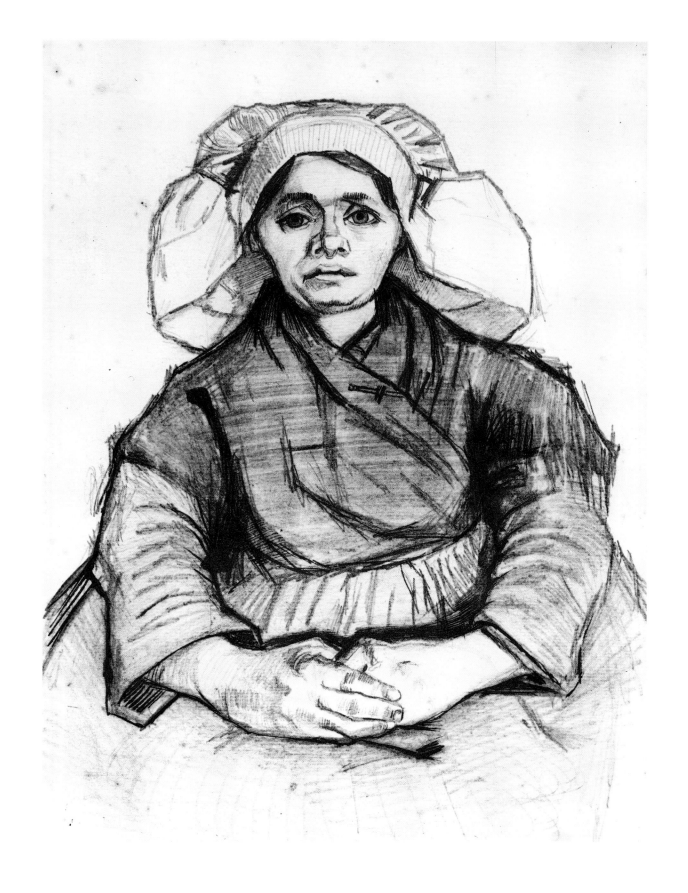

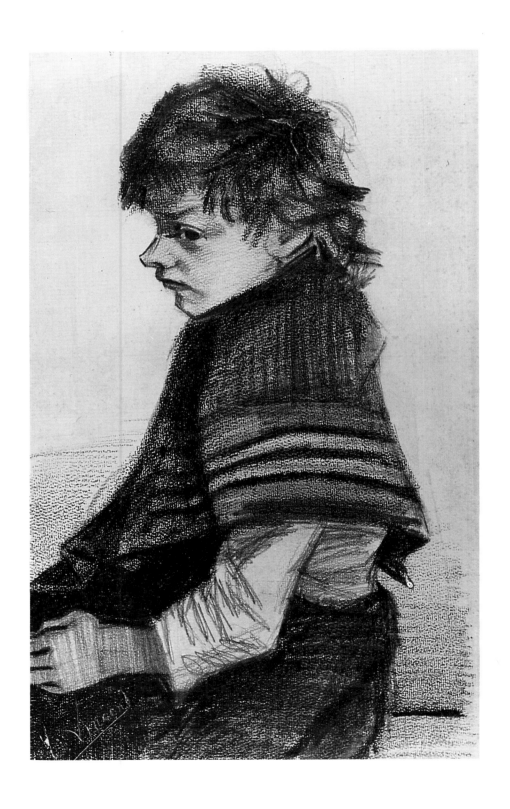

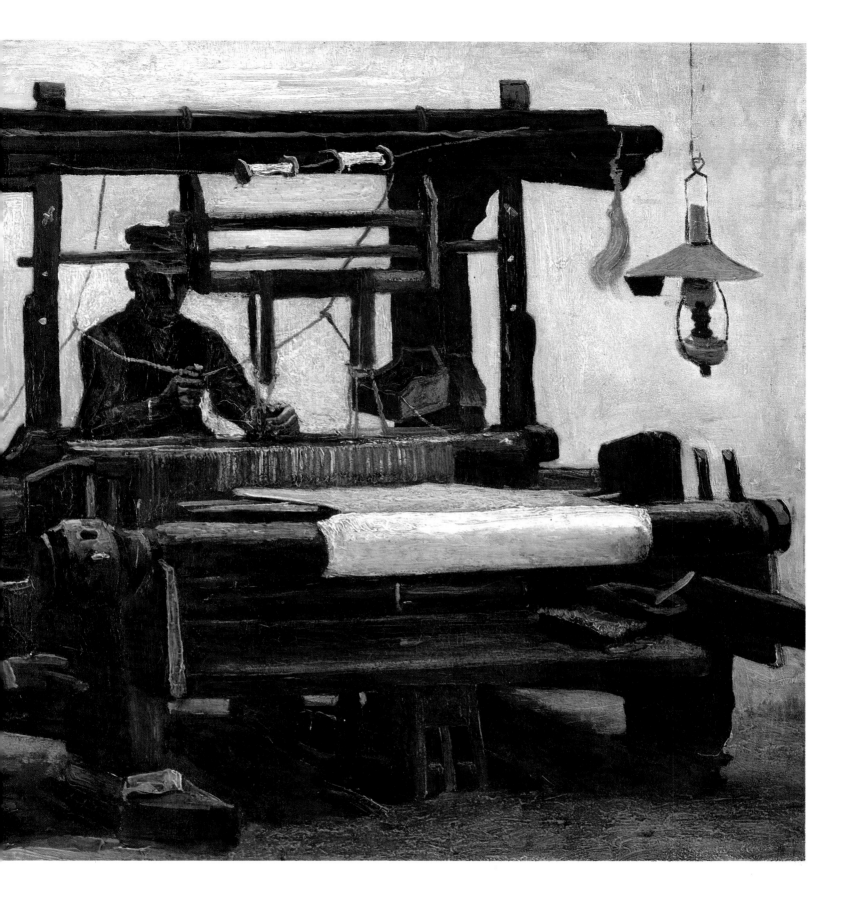

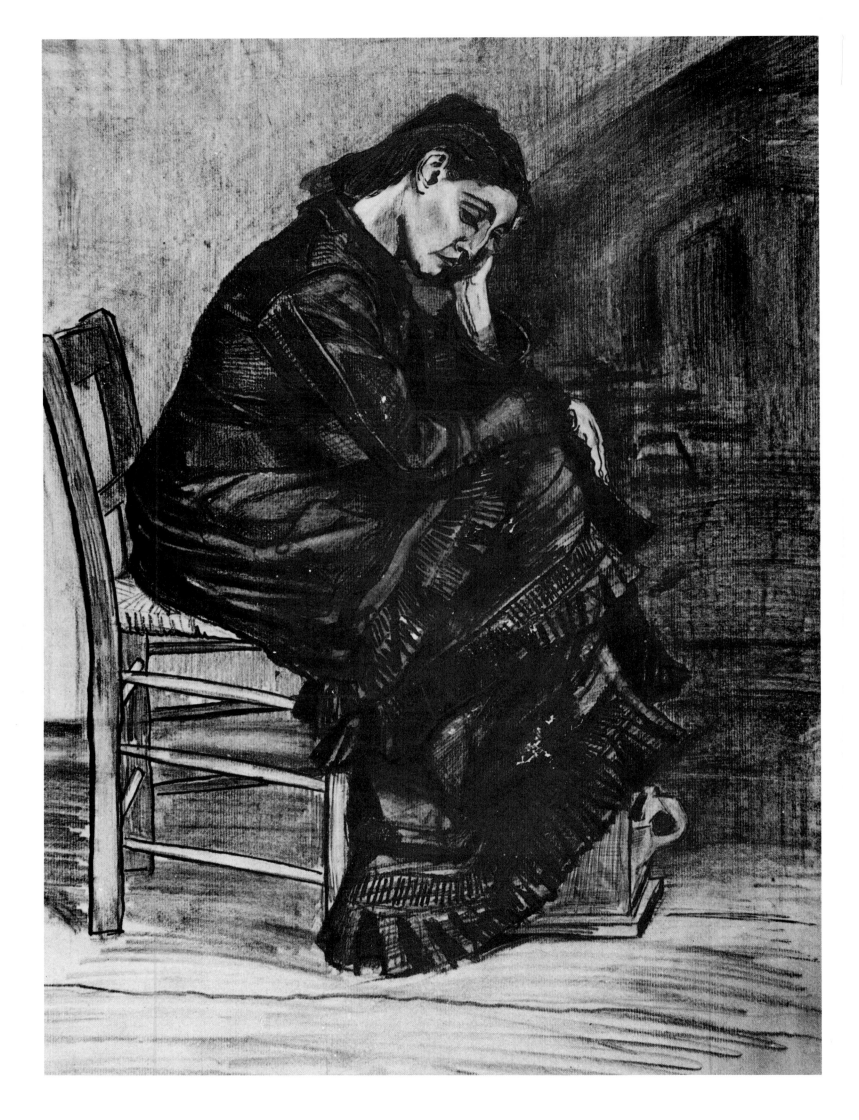

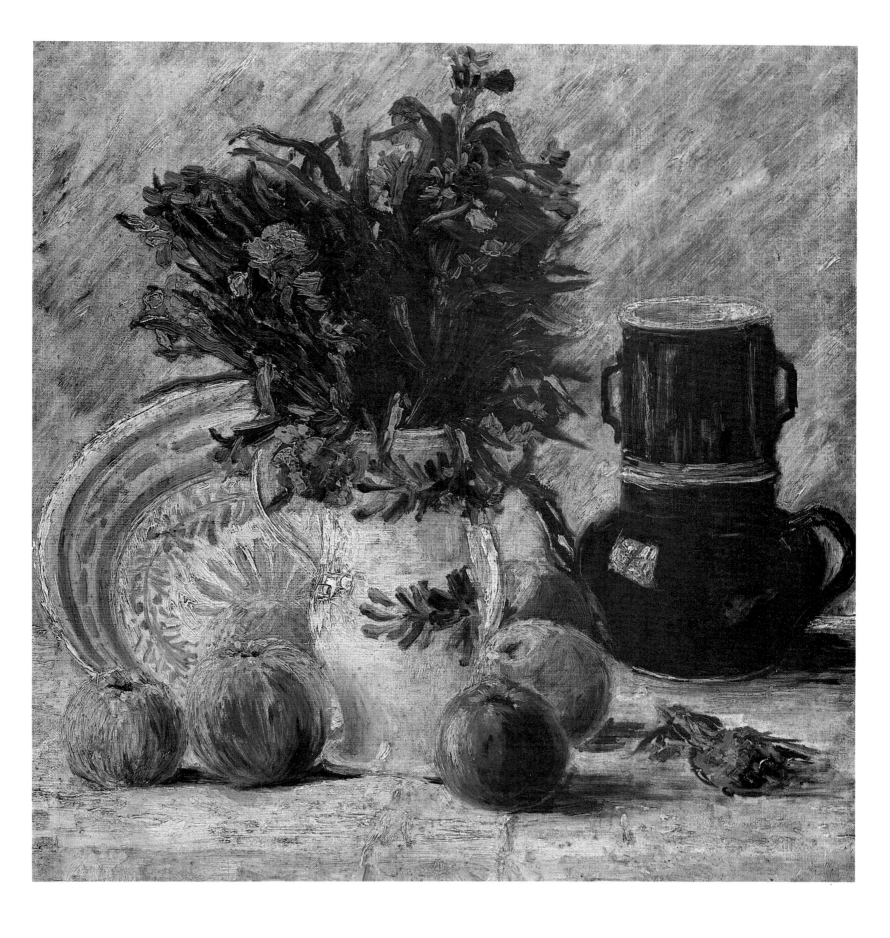

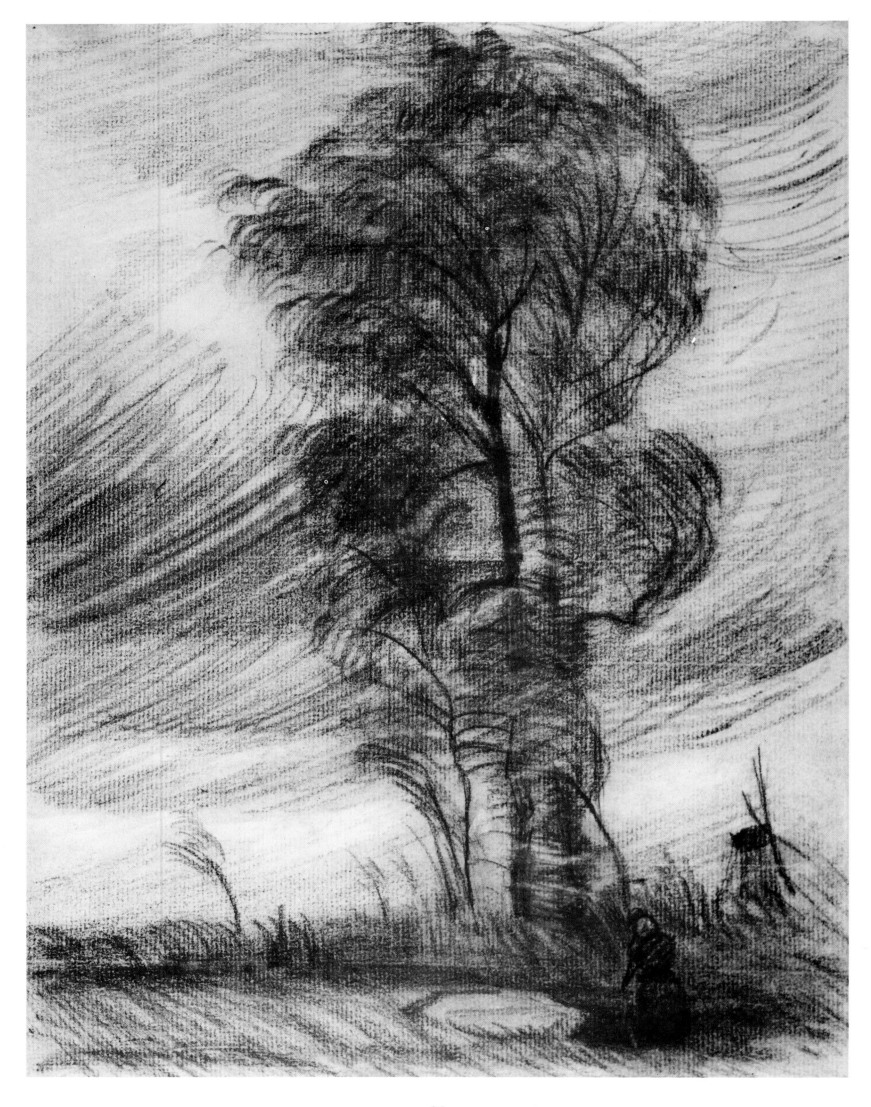

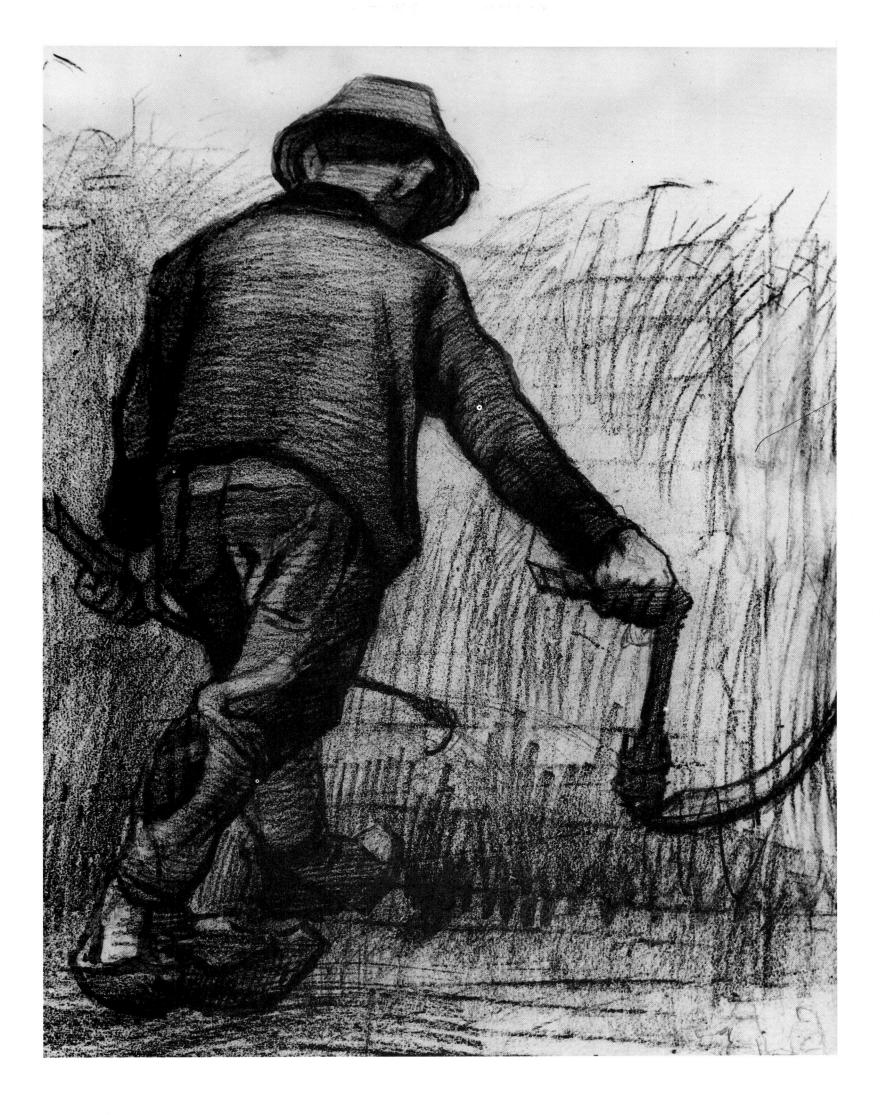

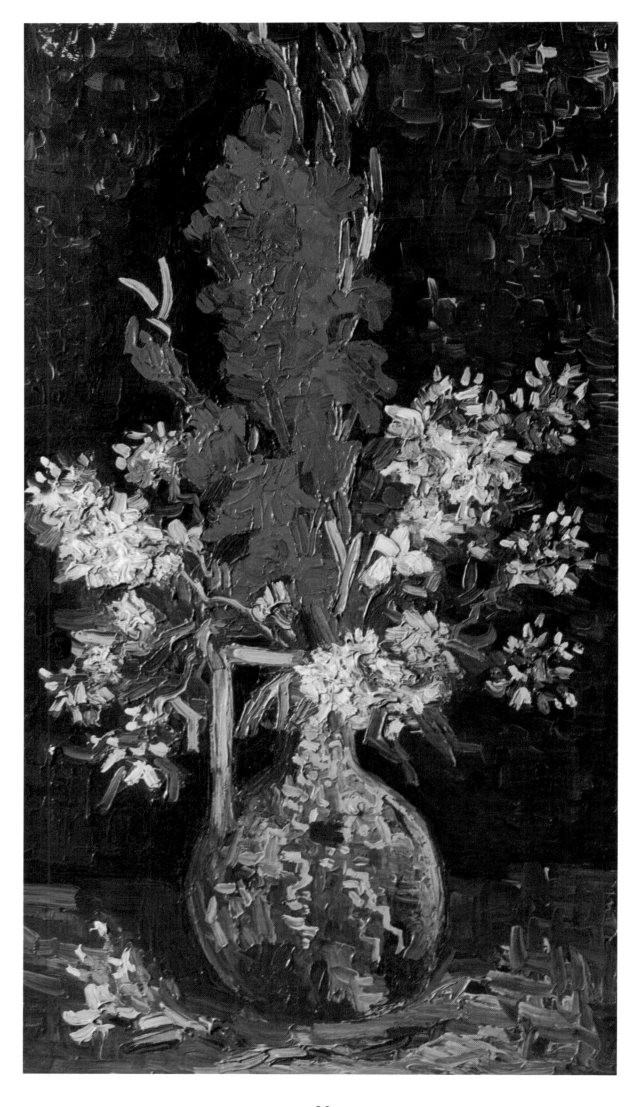

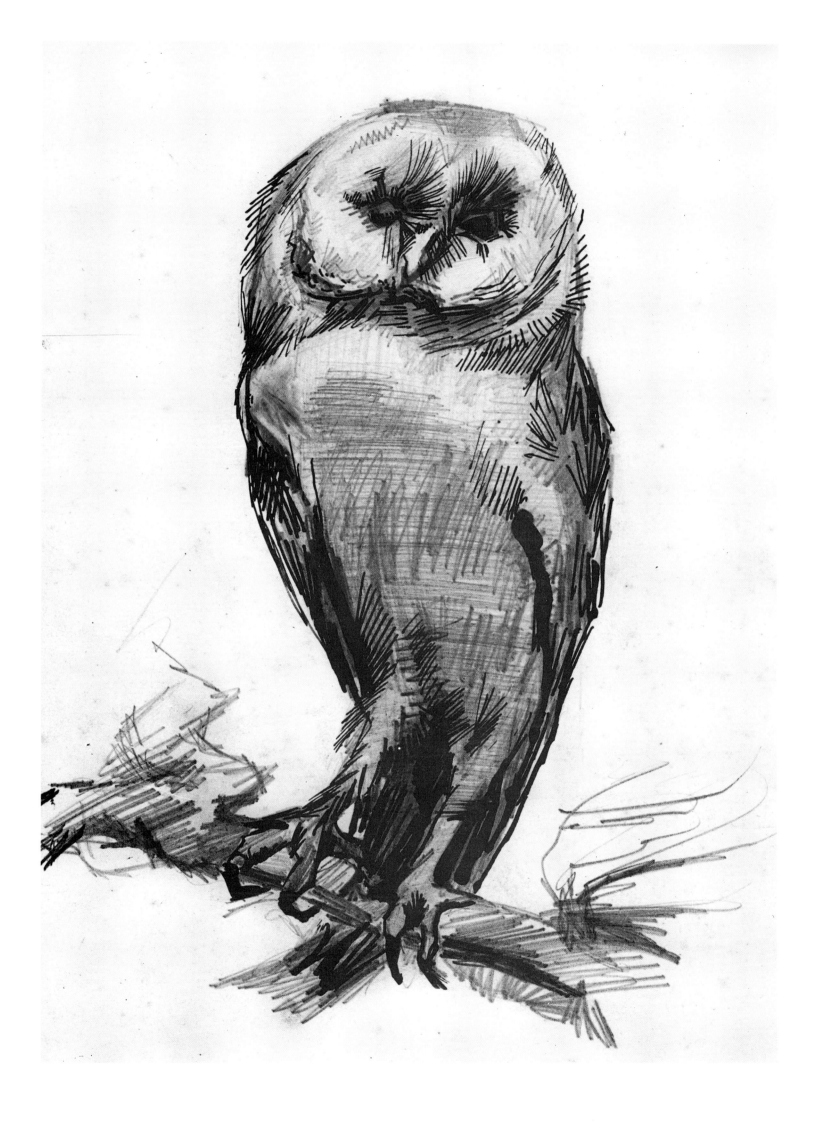

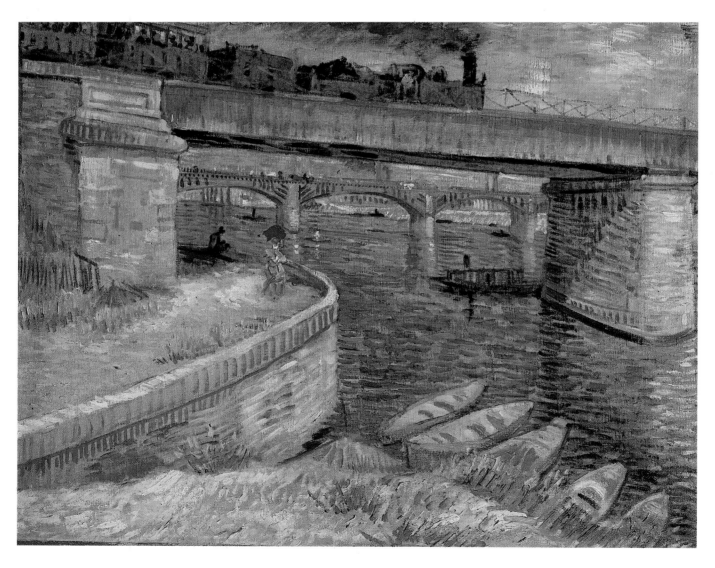

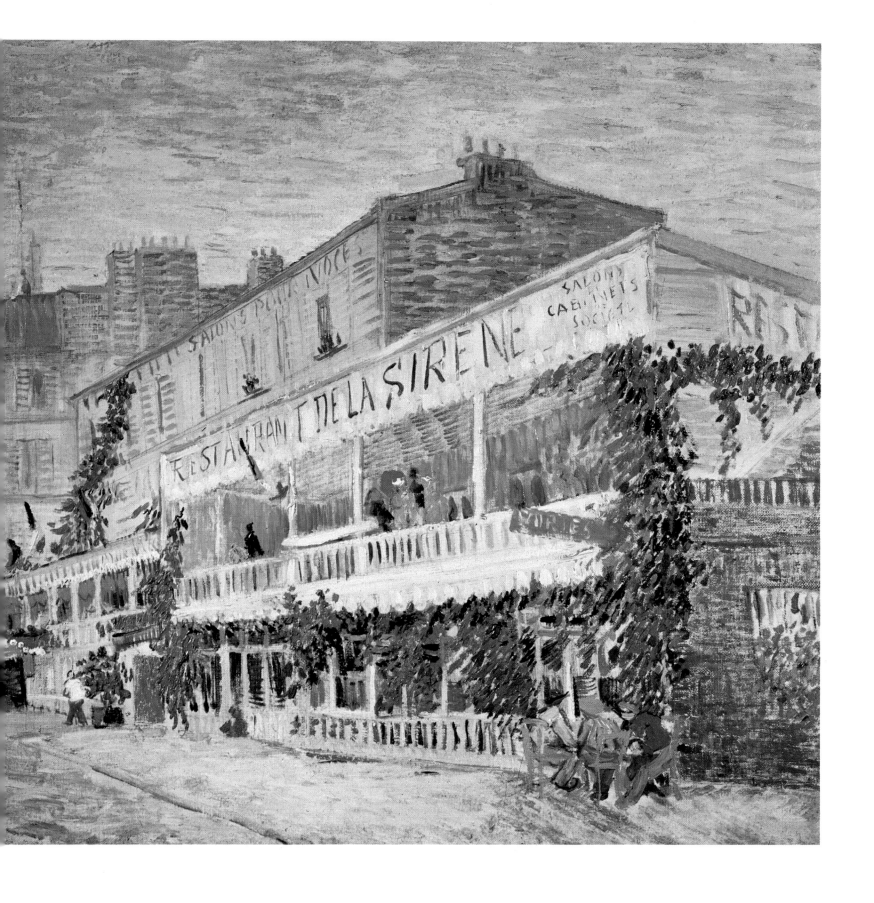

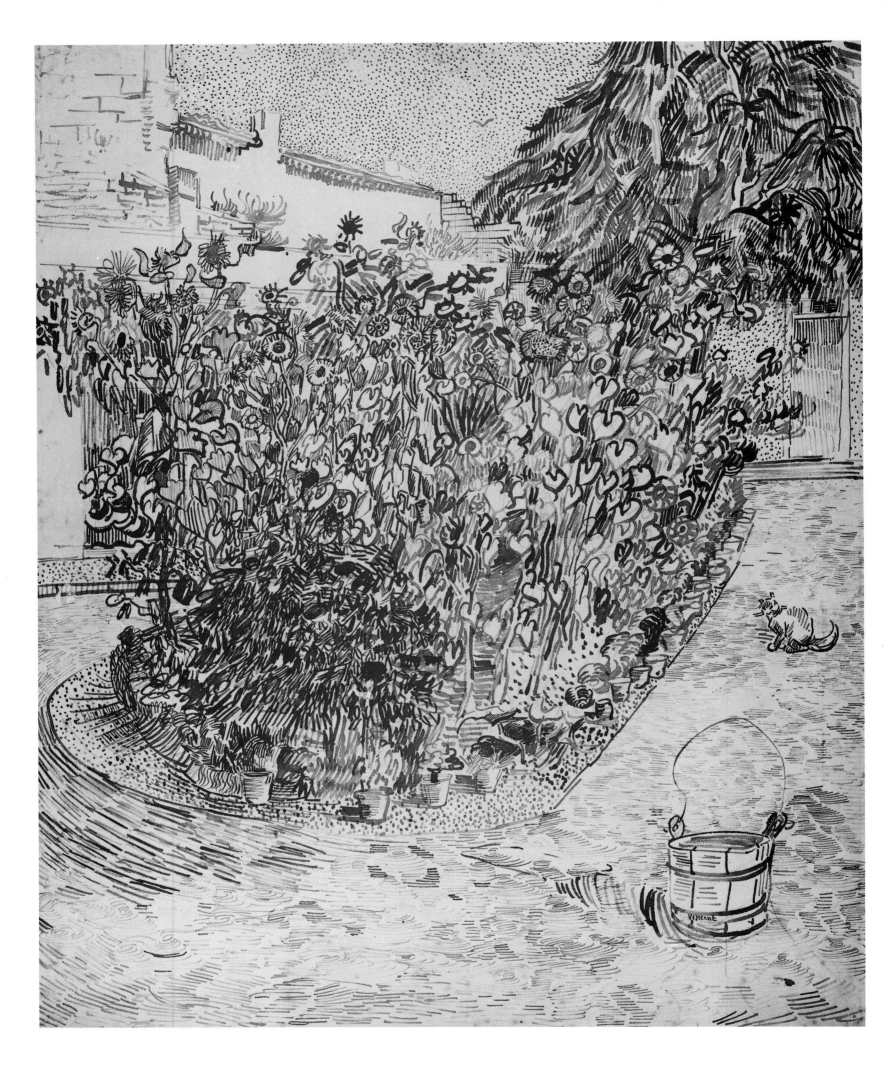

36

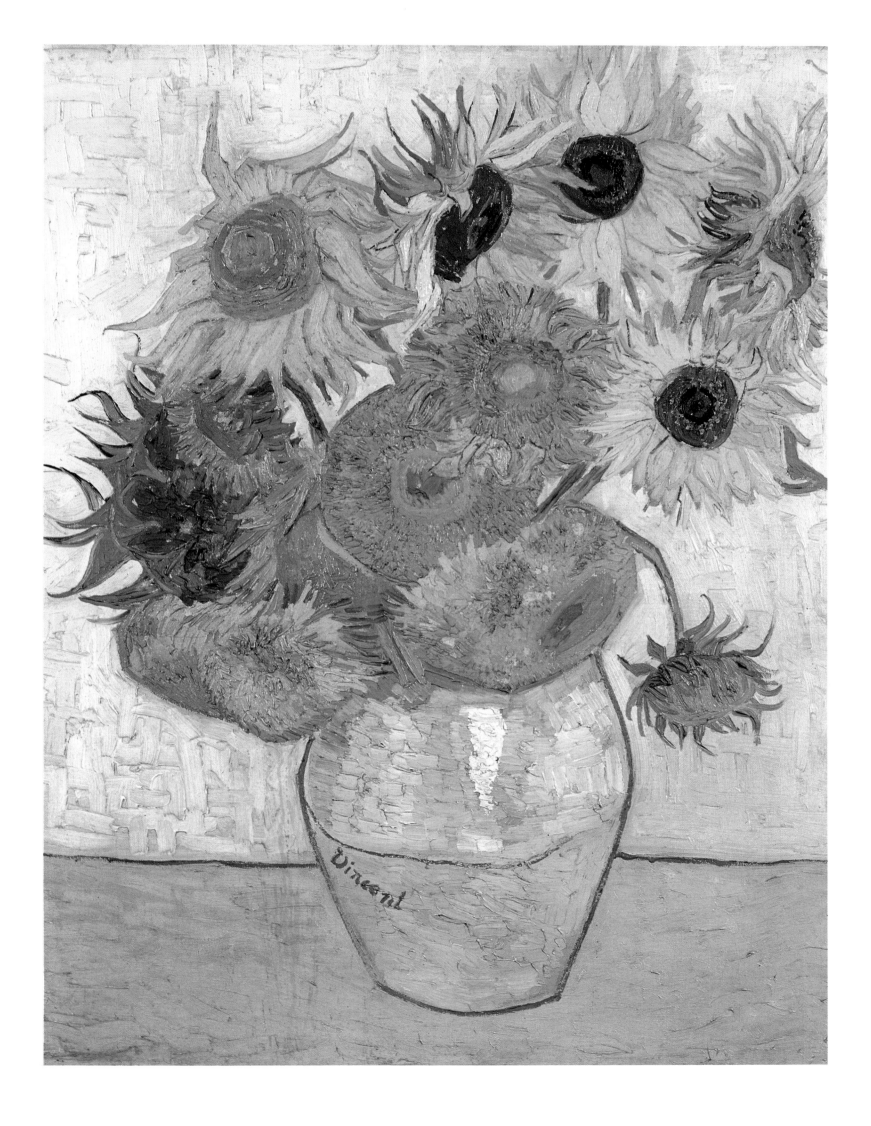

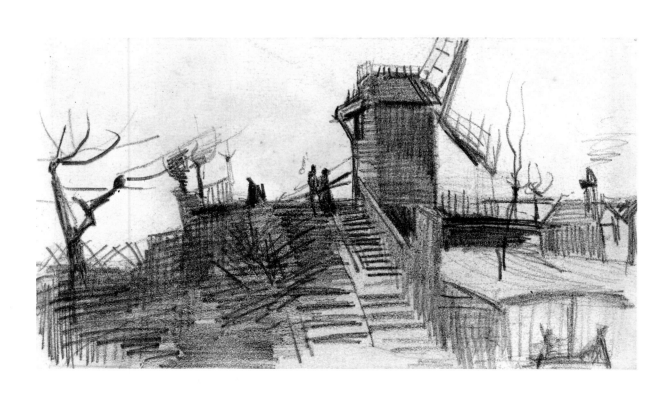

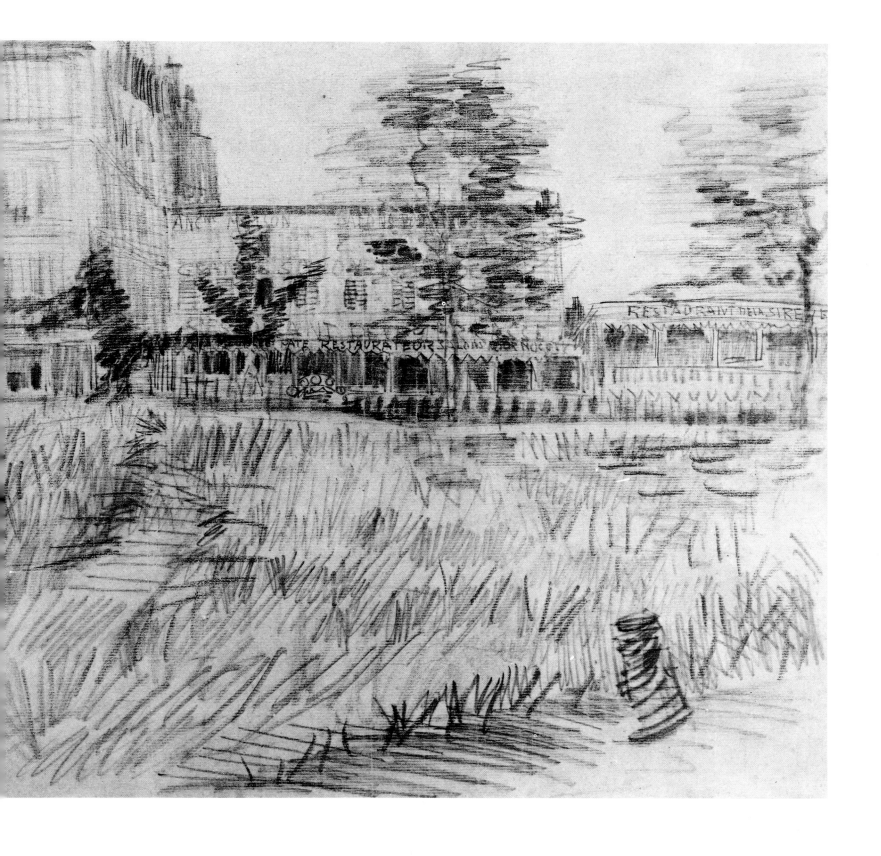

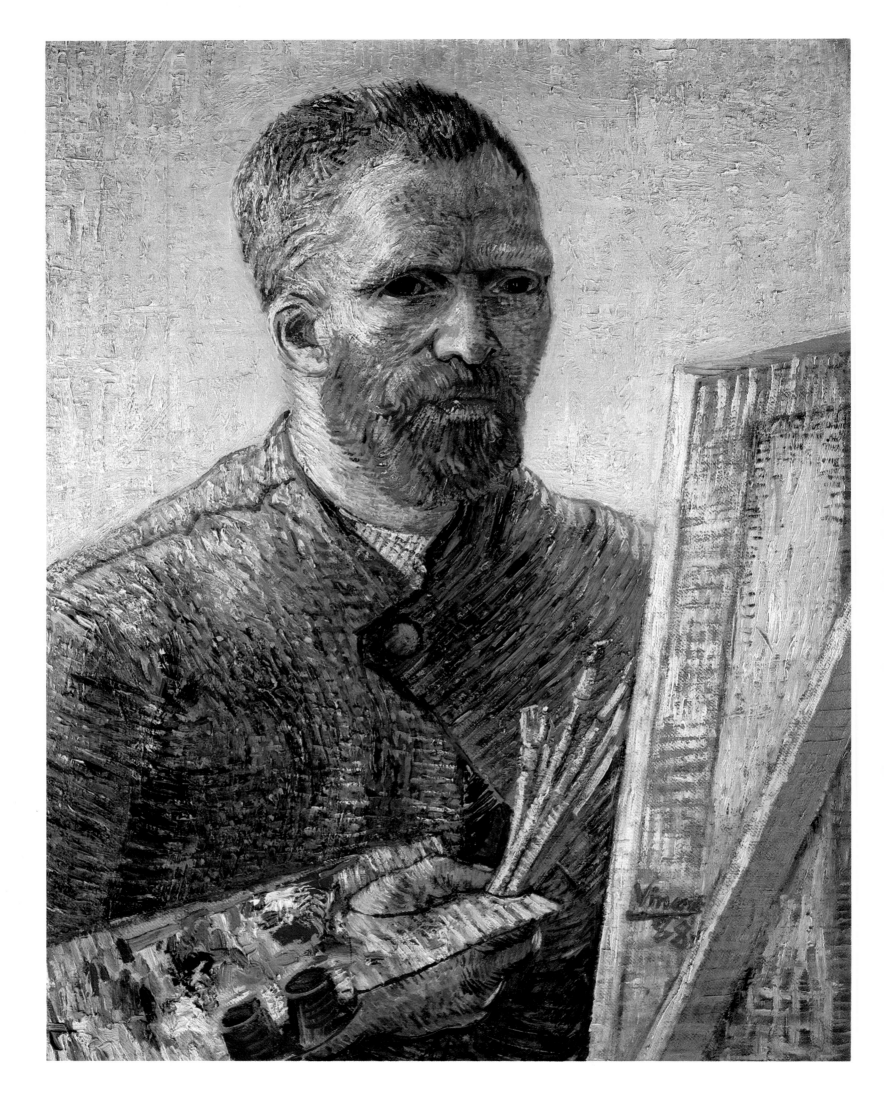

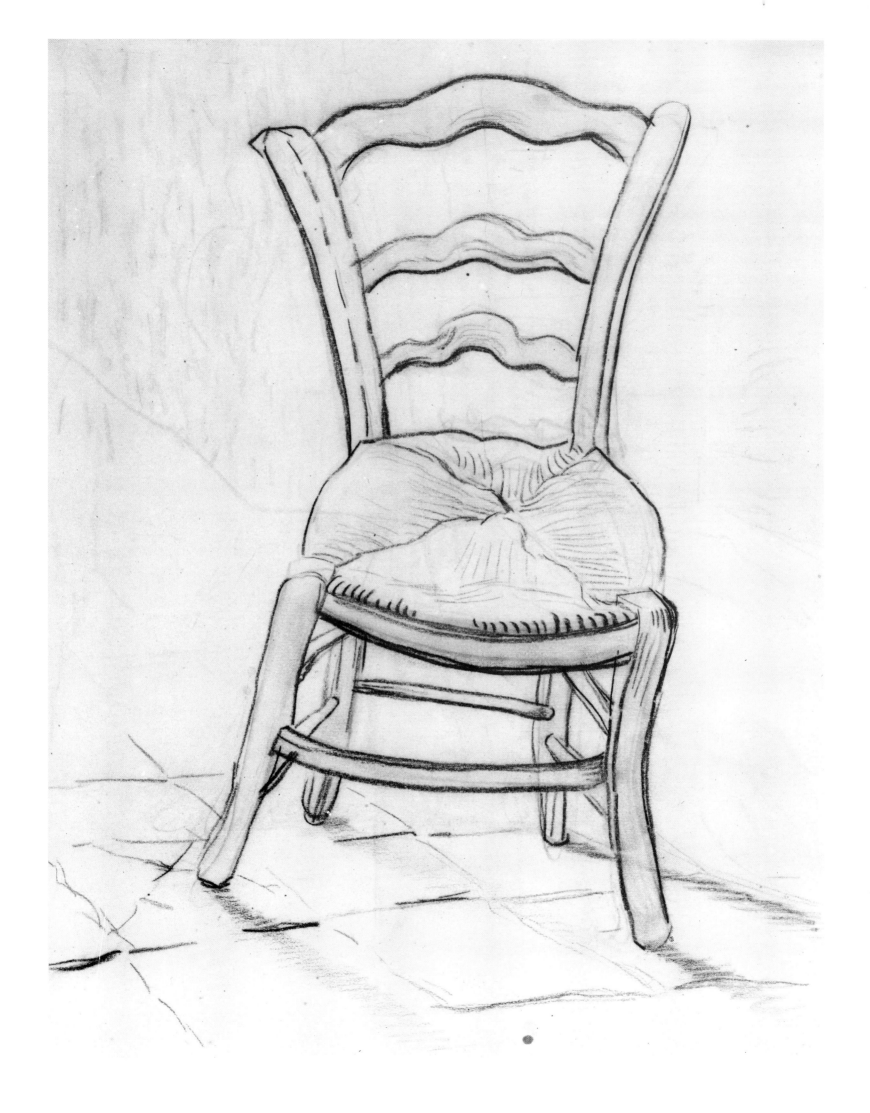

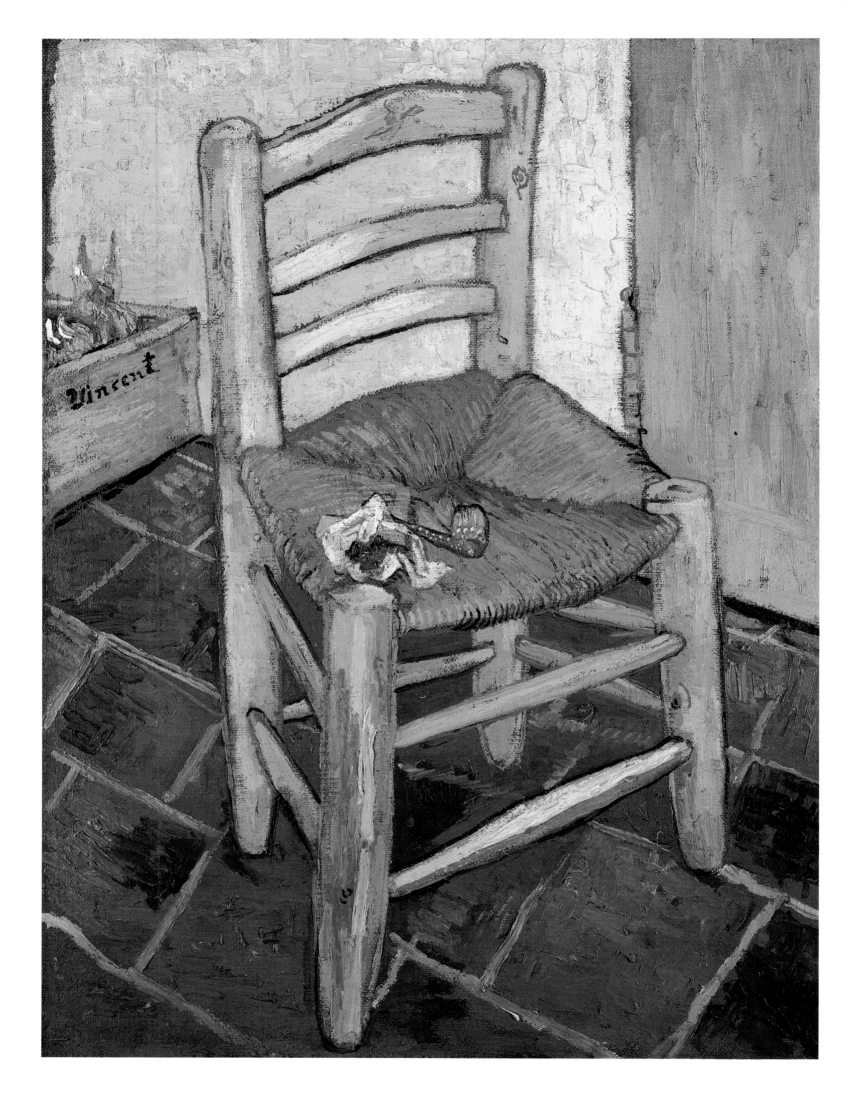

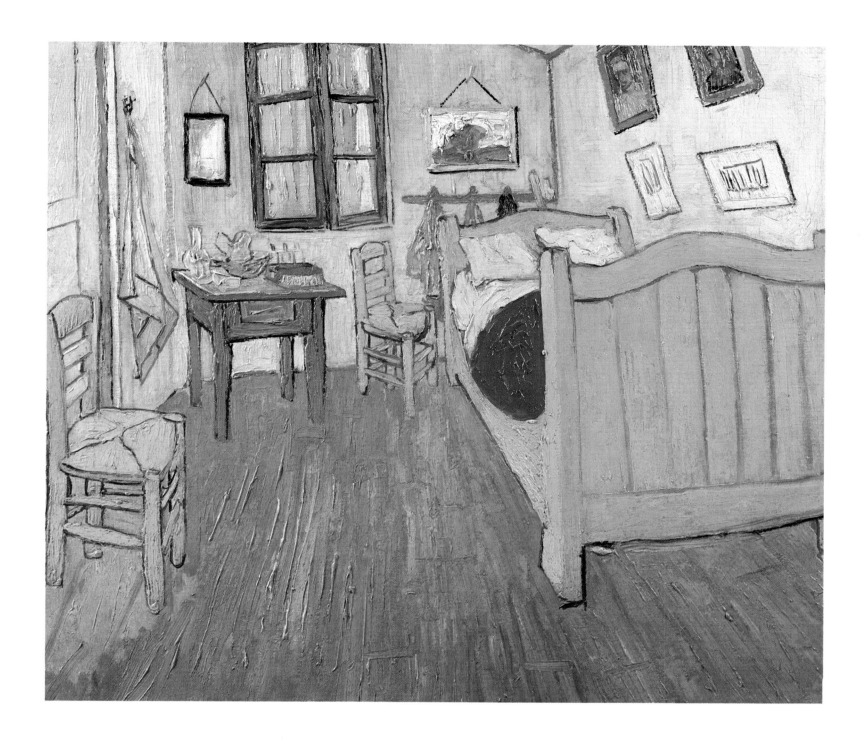

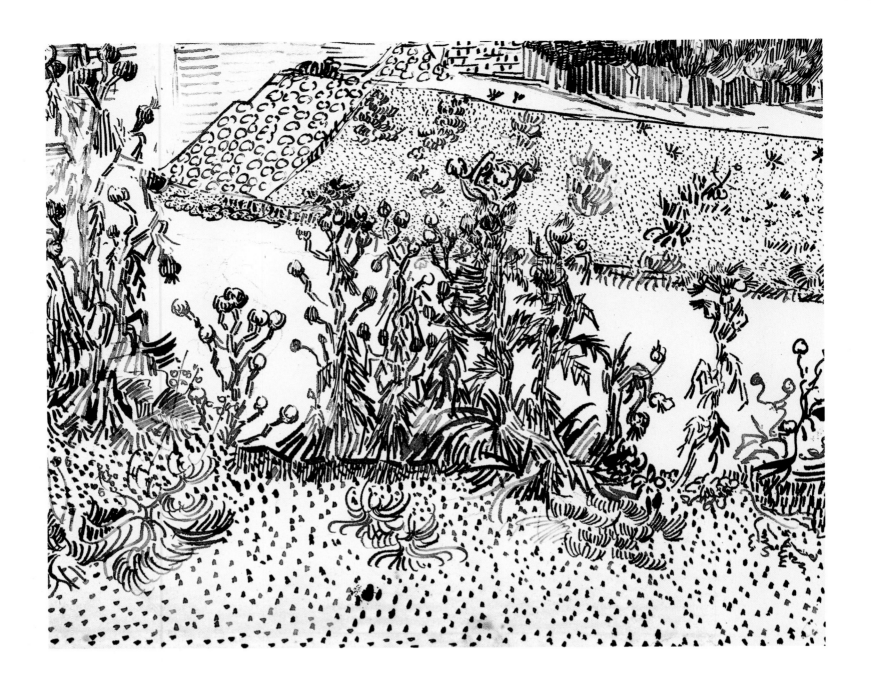

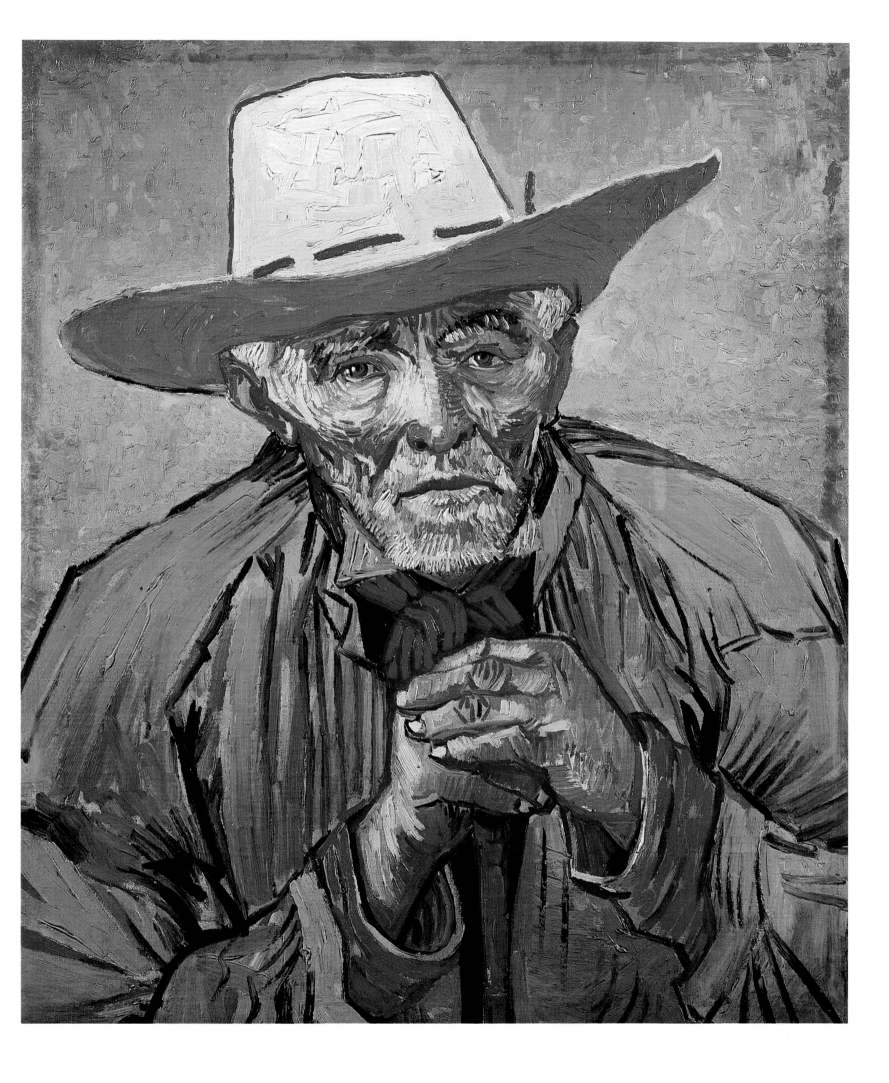

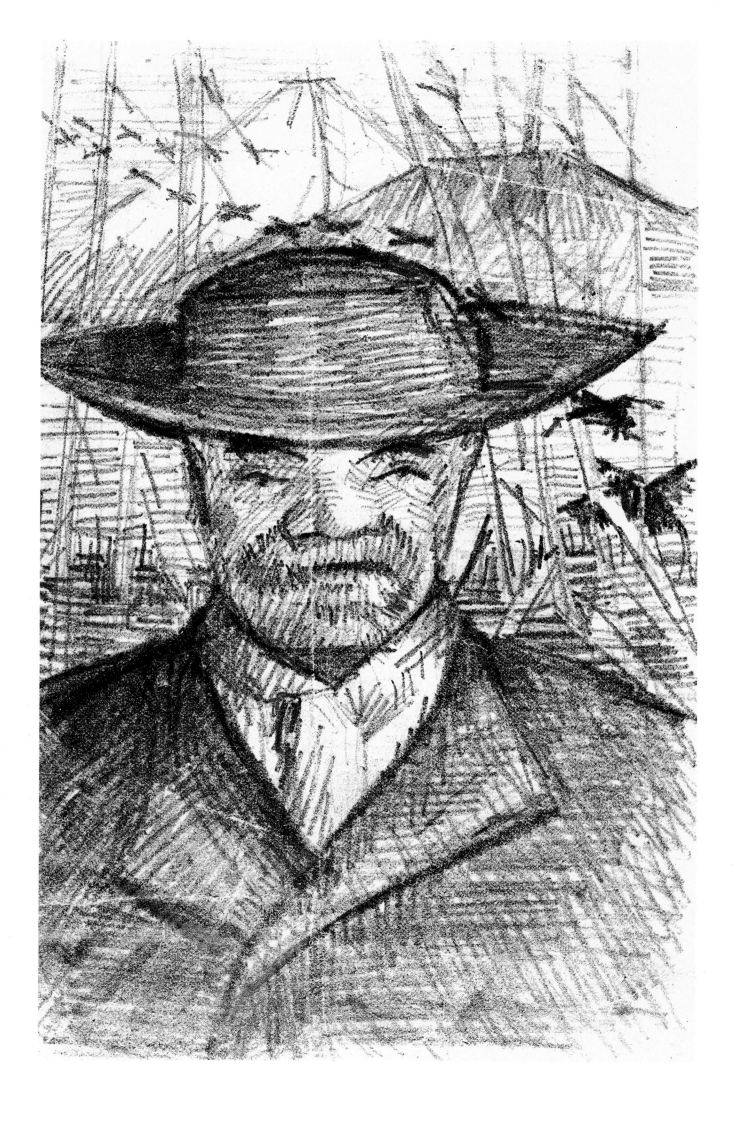

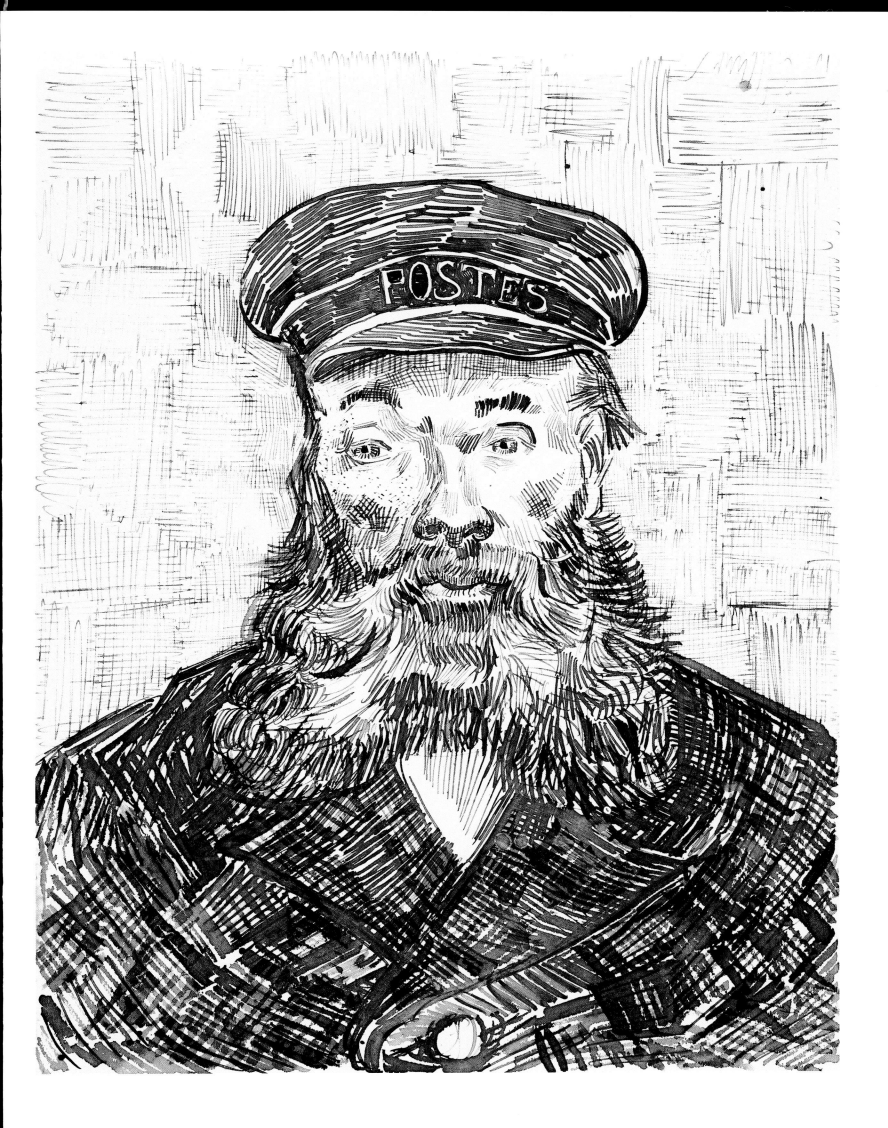

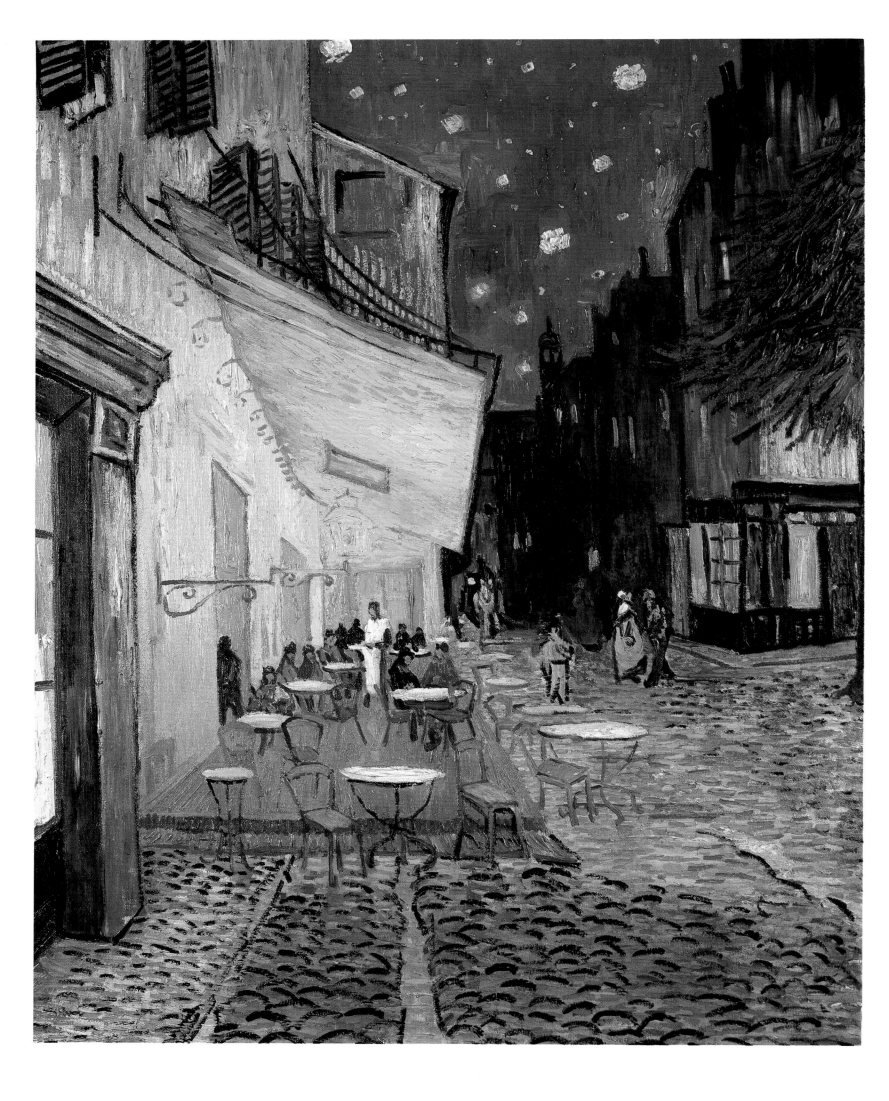

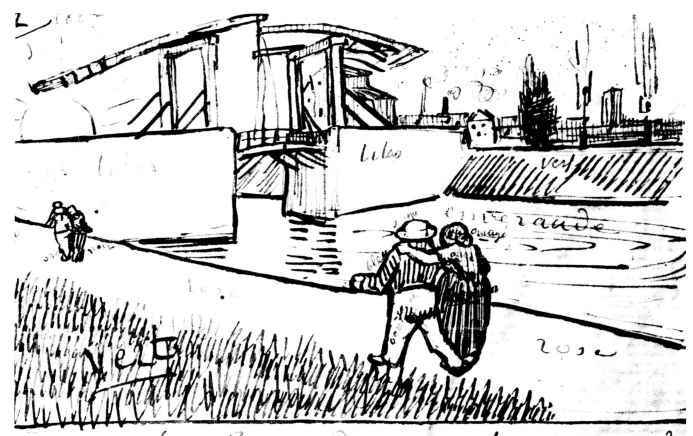

Mon cher Bernard, ayant promis de
l'écrire, je veux commencer par te
dire que le pays me paraît aussi
beau que le Japon pour la limpidité
de l'atmosphère et les effets de couleur
gai. Les eaux font des tâches d'un
bel émeraude et d'un riche bleu dans le
paysages ainsi que nous le voyons
dans les crepons. Des couchers de sole
orangé pâle faisant paraître bleu les
terrains. Des soleils jaunes splen
Cependant je n'ai encore guère vu le
pays dans sa splendeur habituelle d'été
Le costume des femmes est joli et le dimanc
surtout on voit sur le boulevard des
arrangements de couleur très naïfs et
bien trouvés. Et cela aussi sans doute
s'égay encore en été.

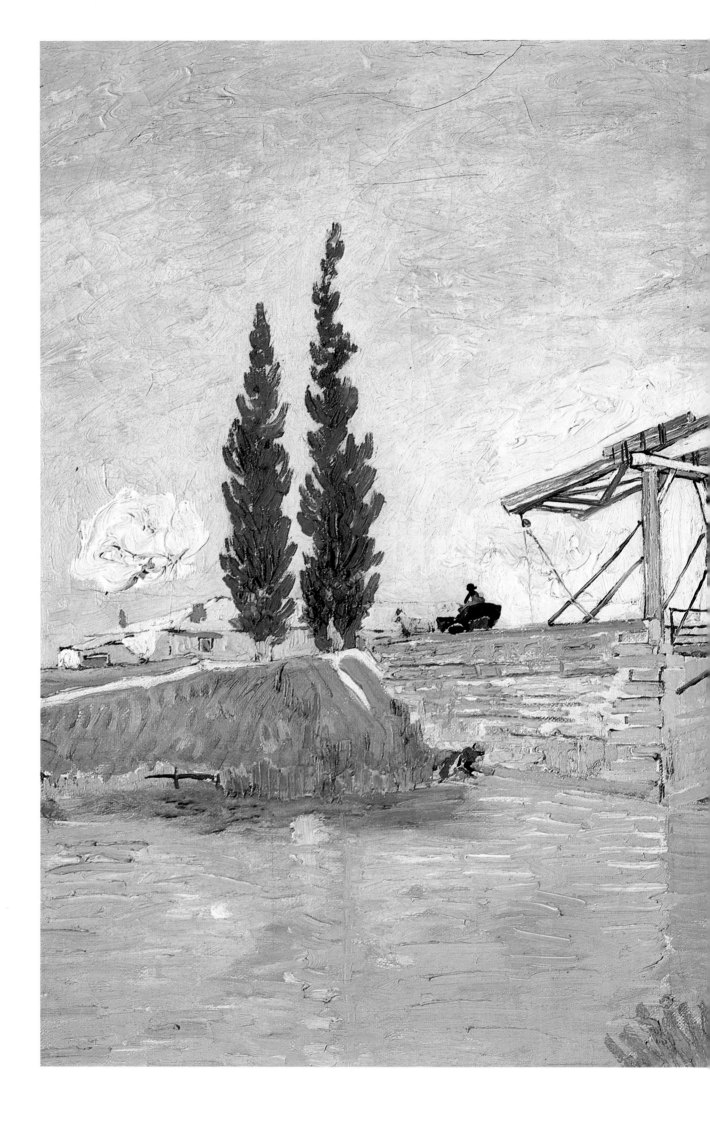

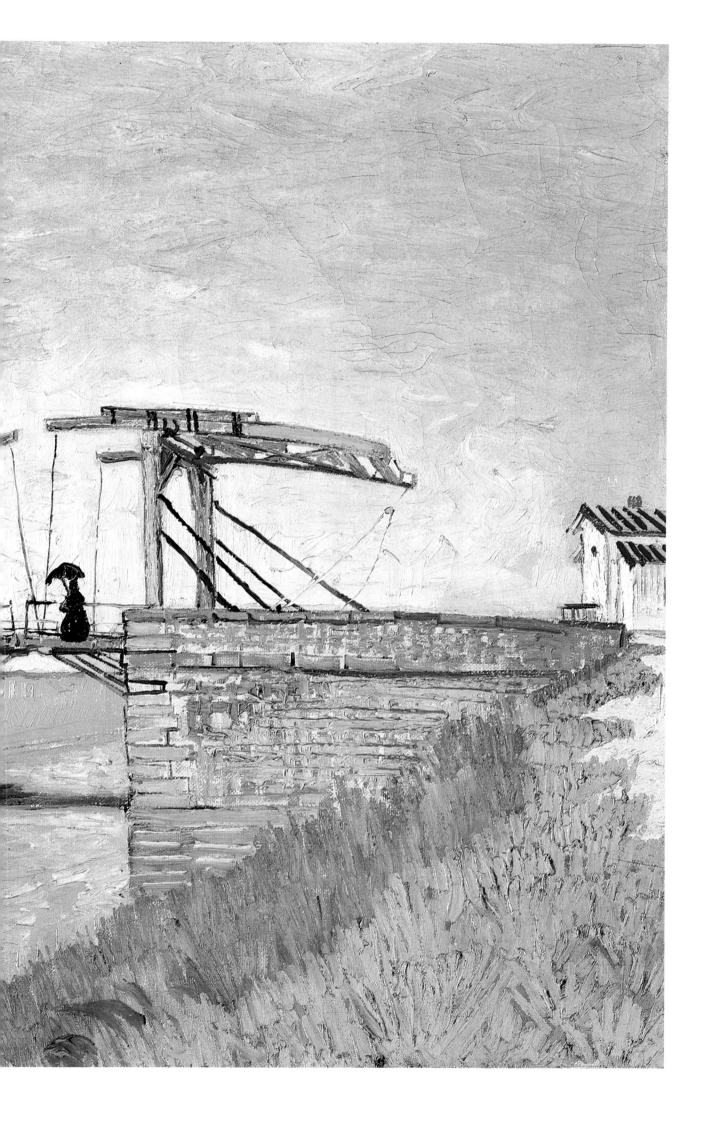

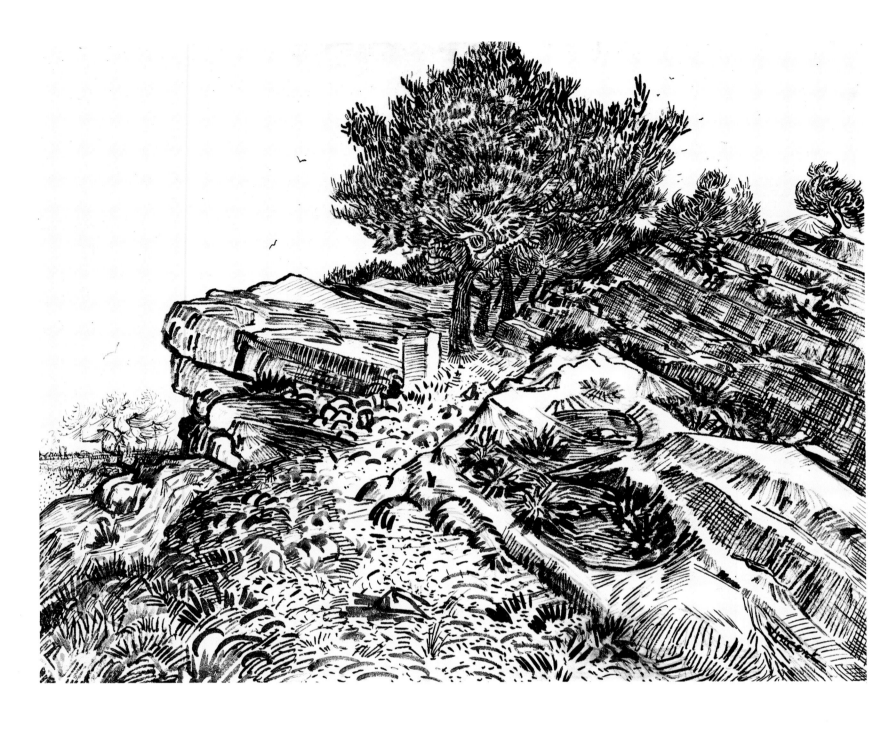

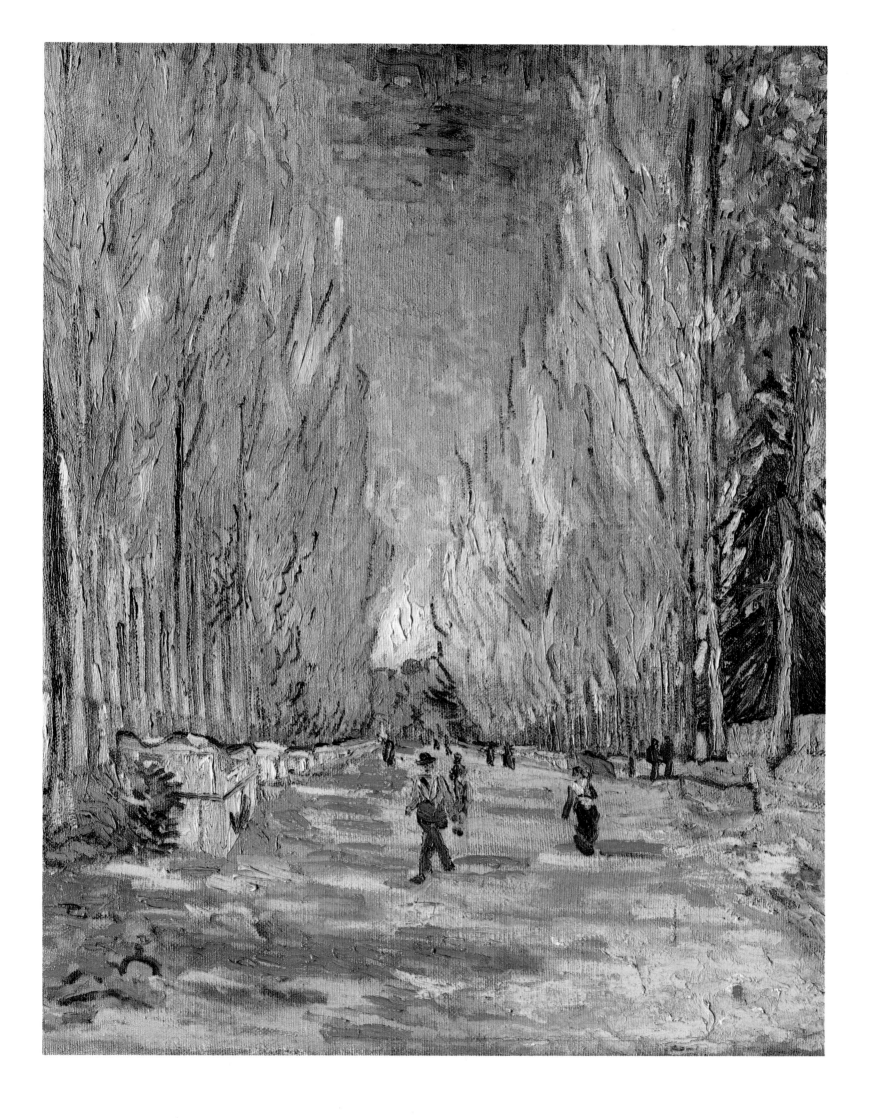

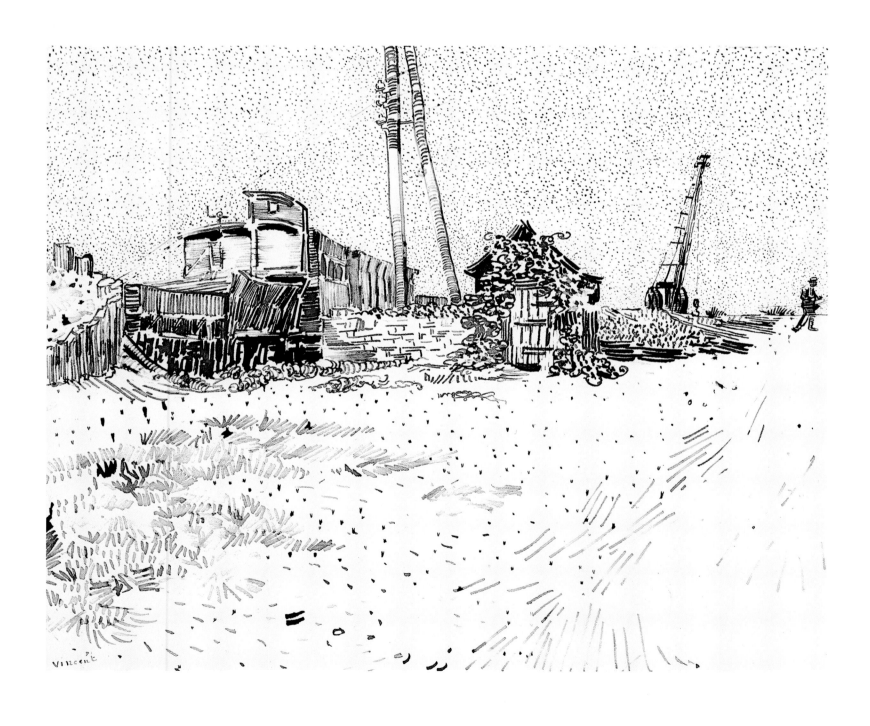

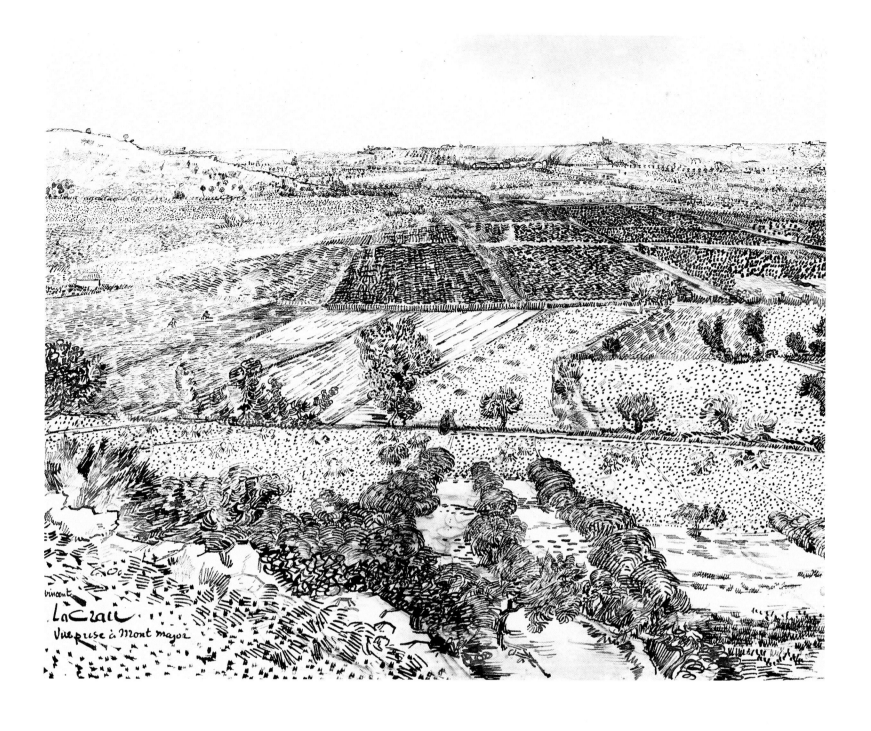

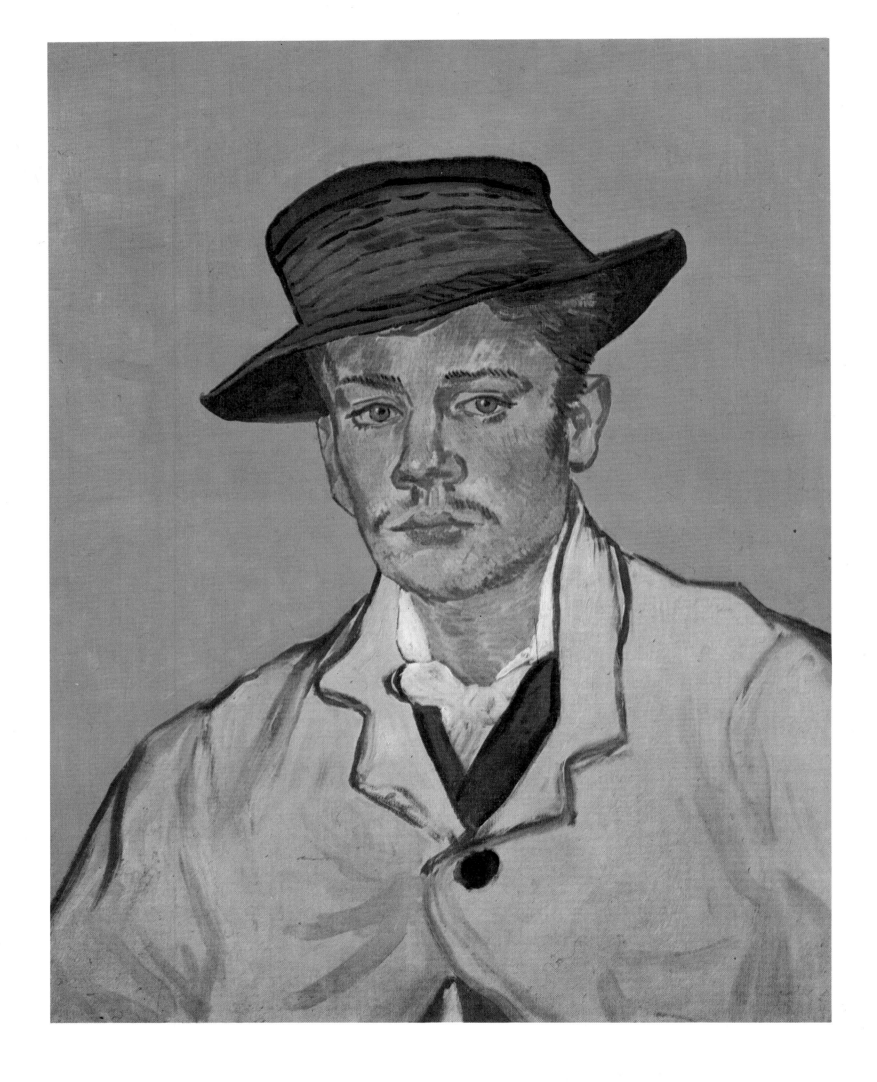

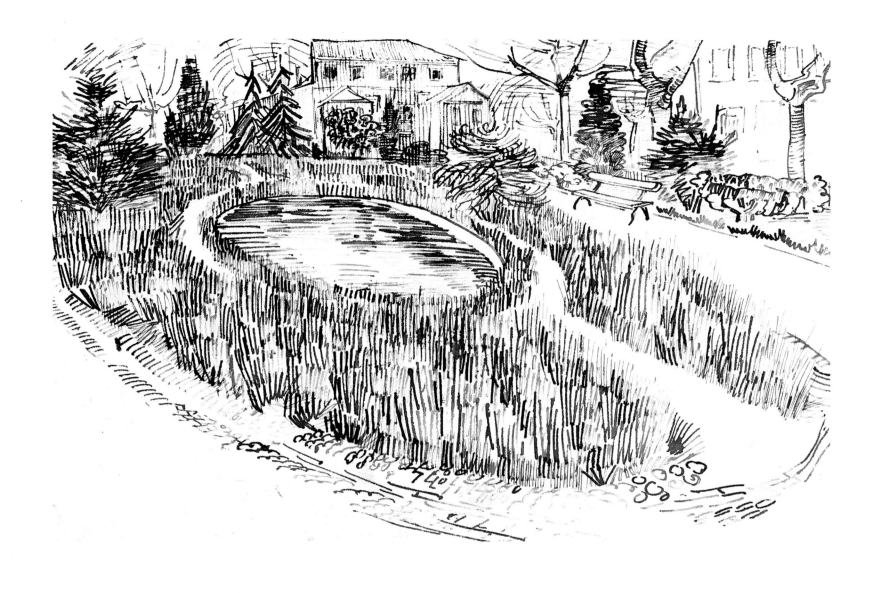

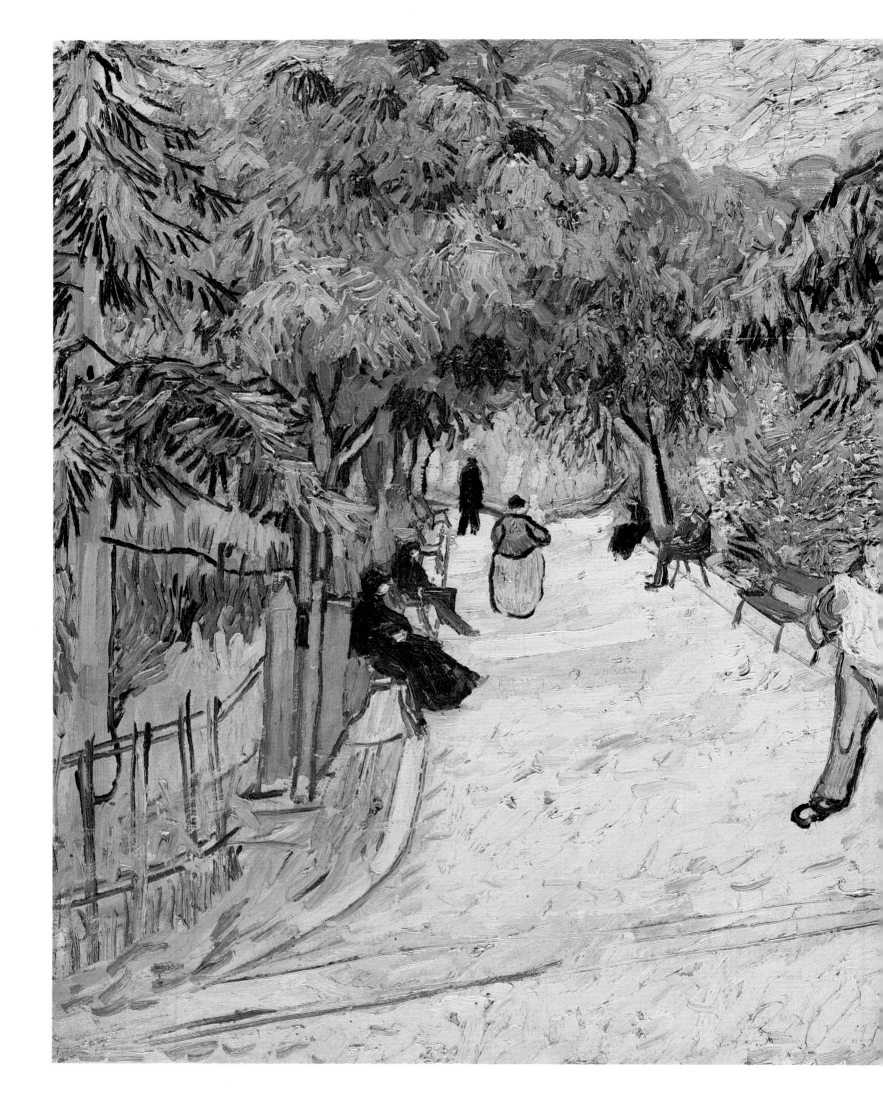

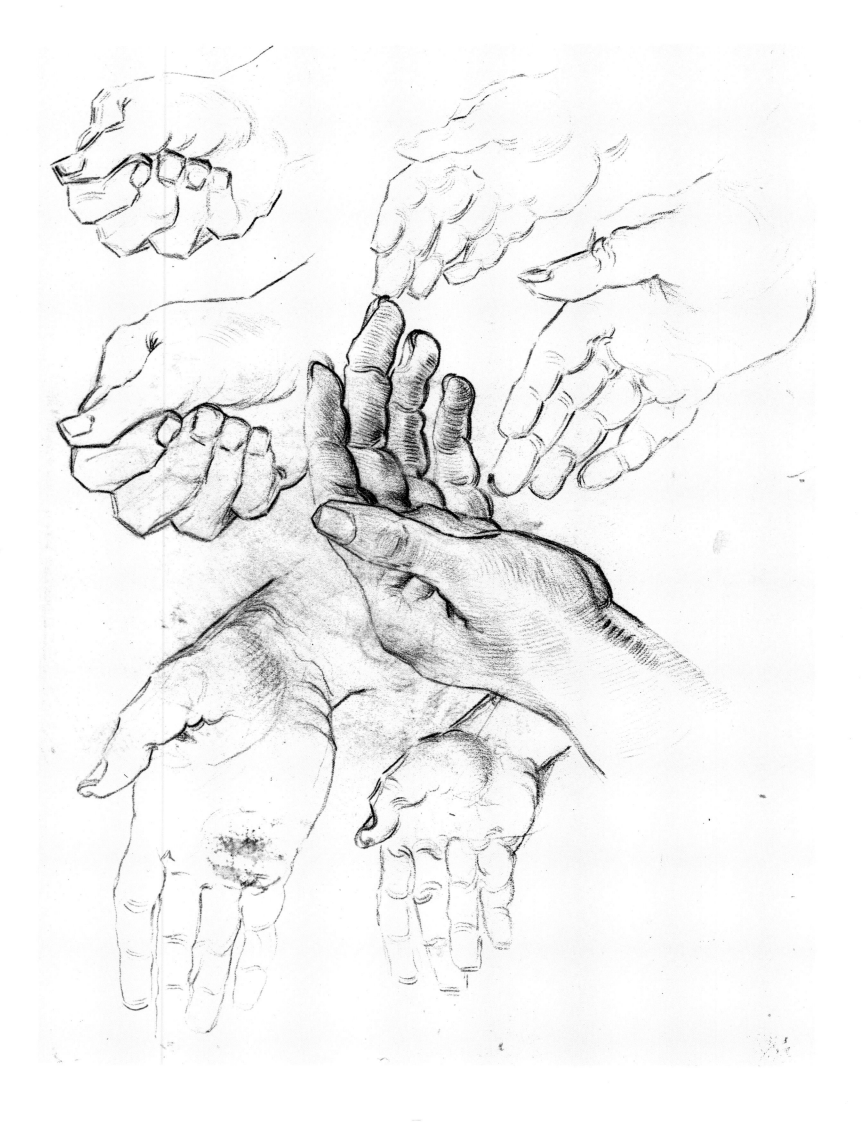

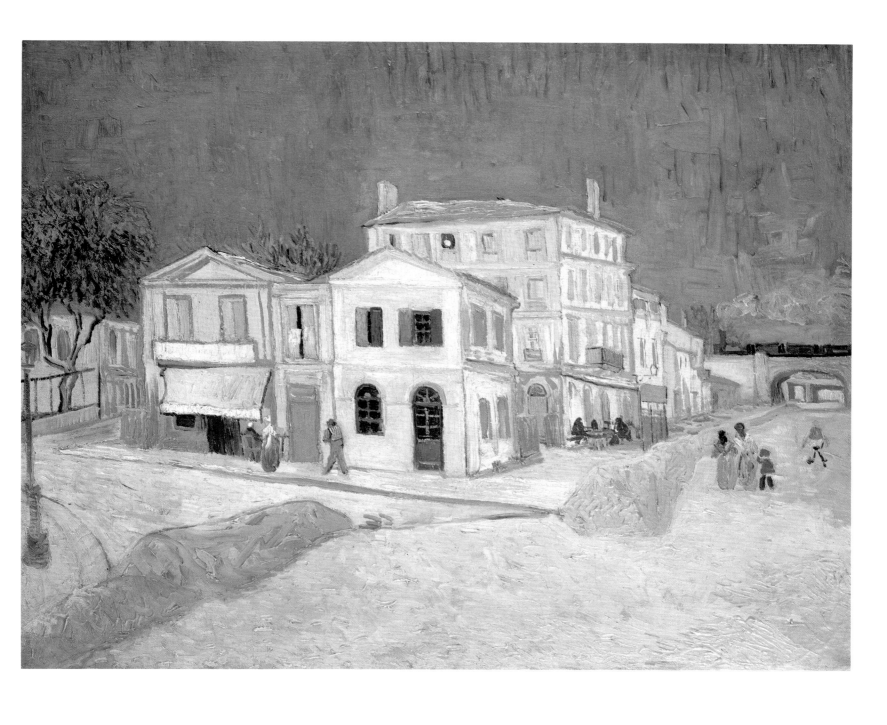

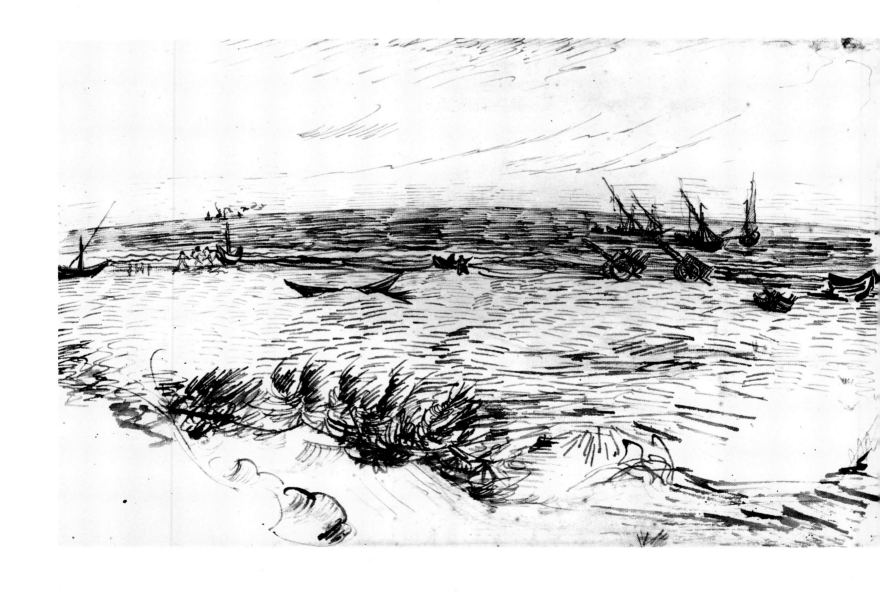

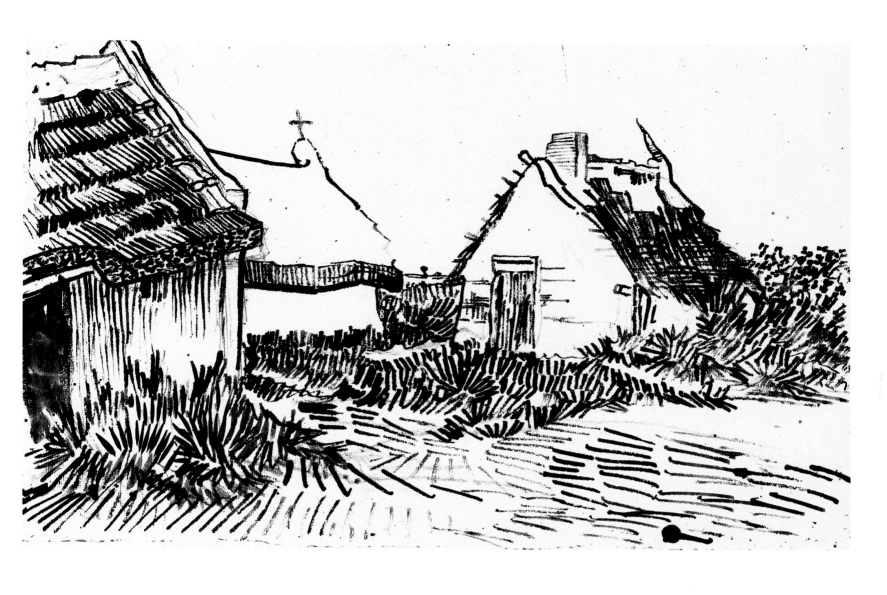

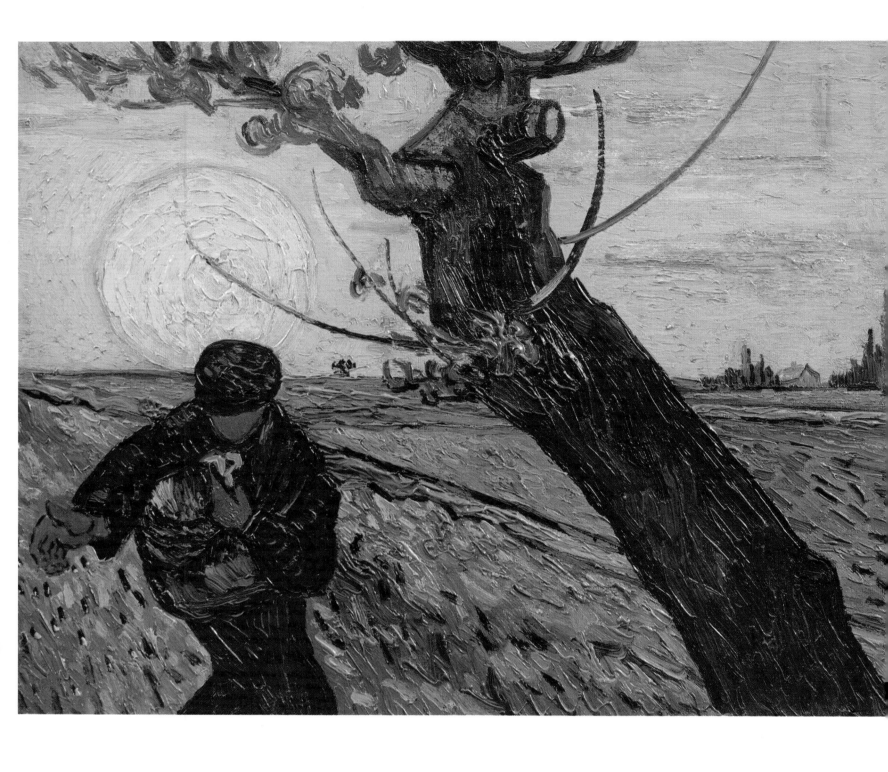

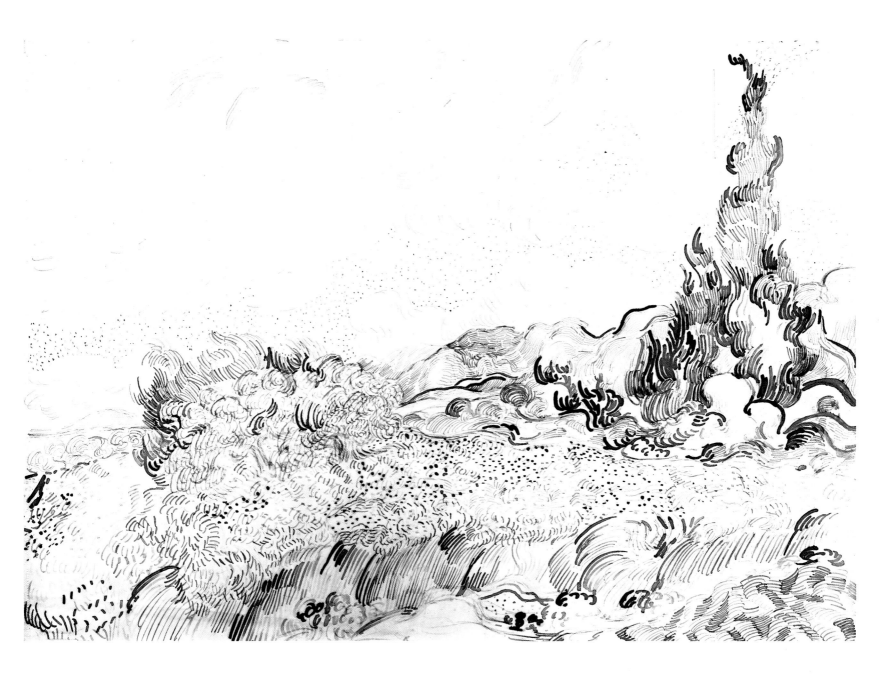

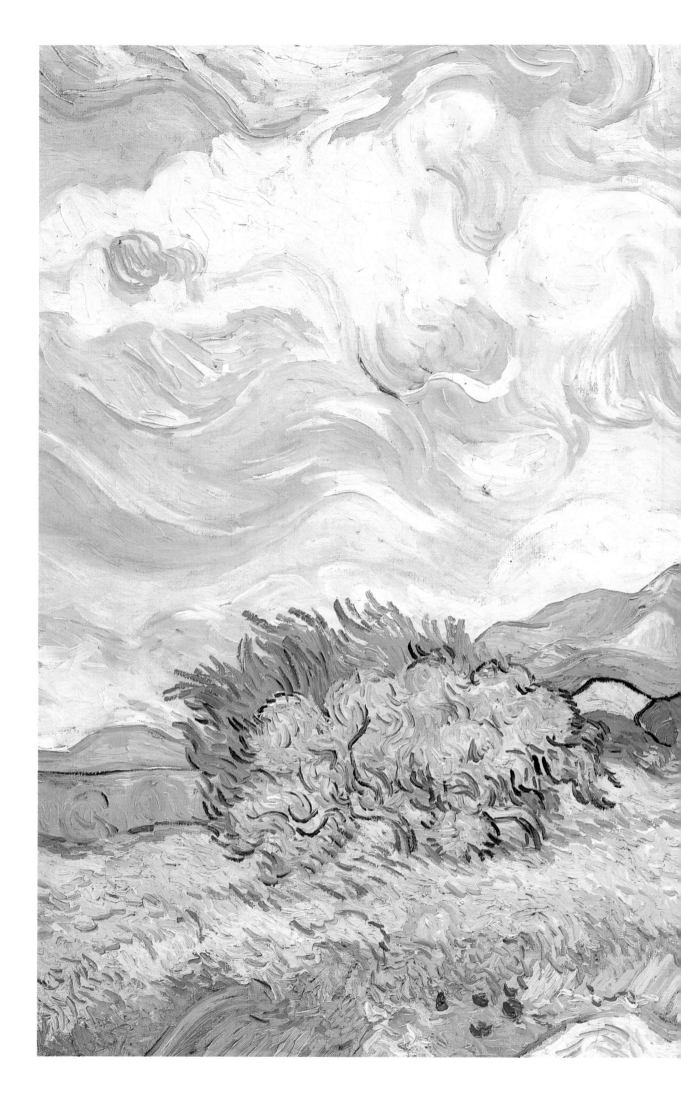

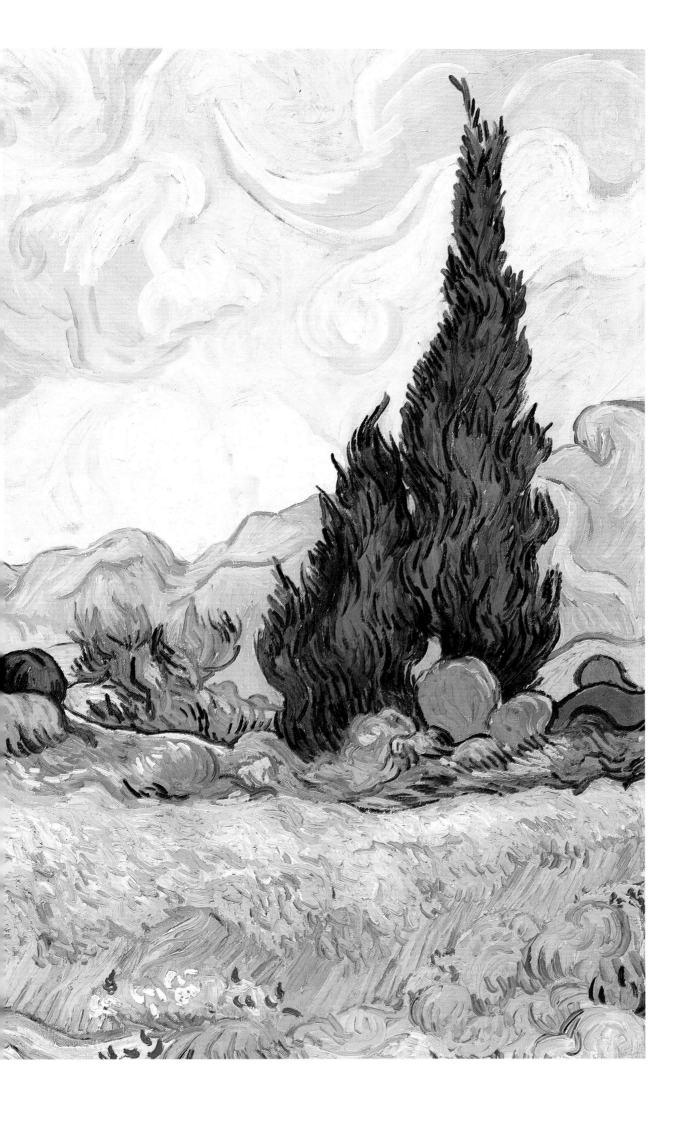

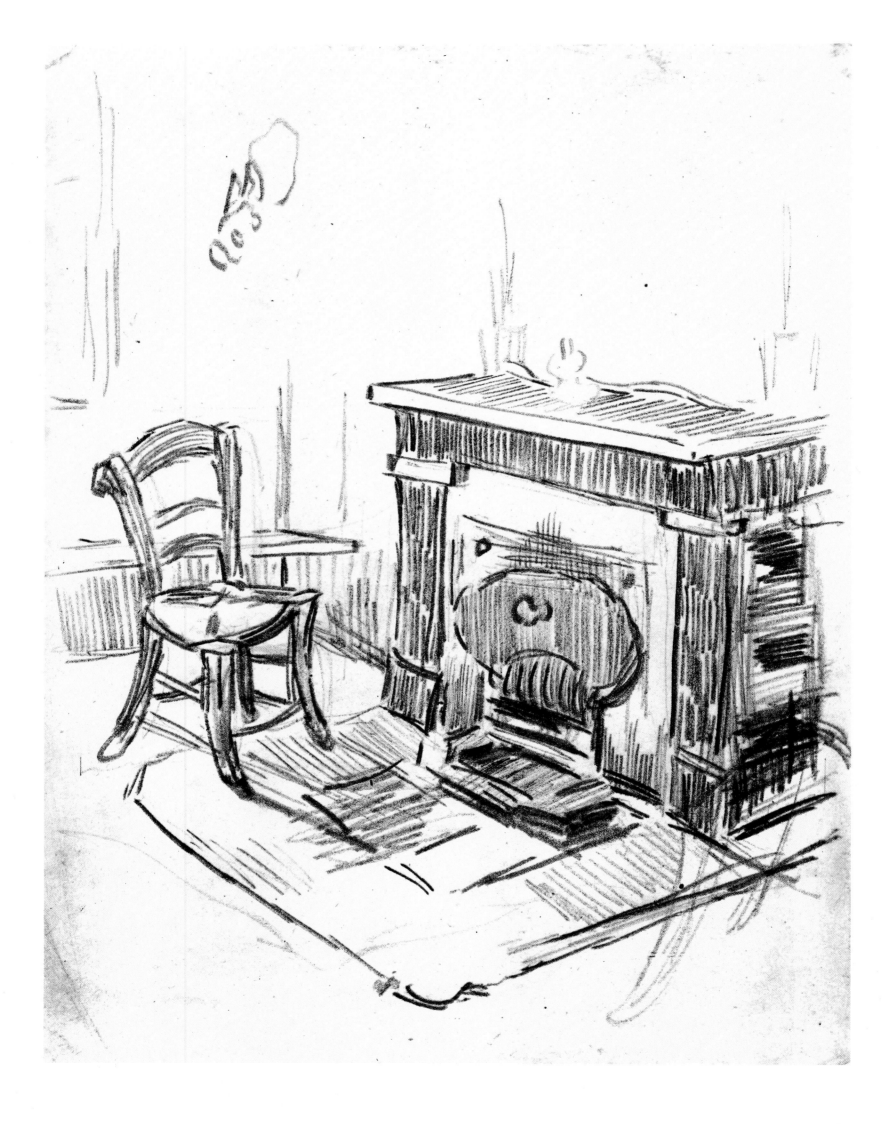

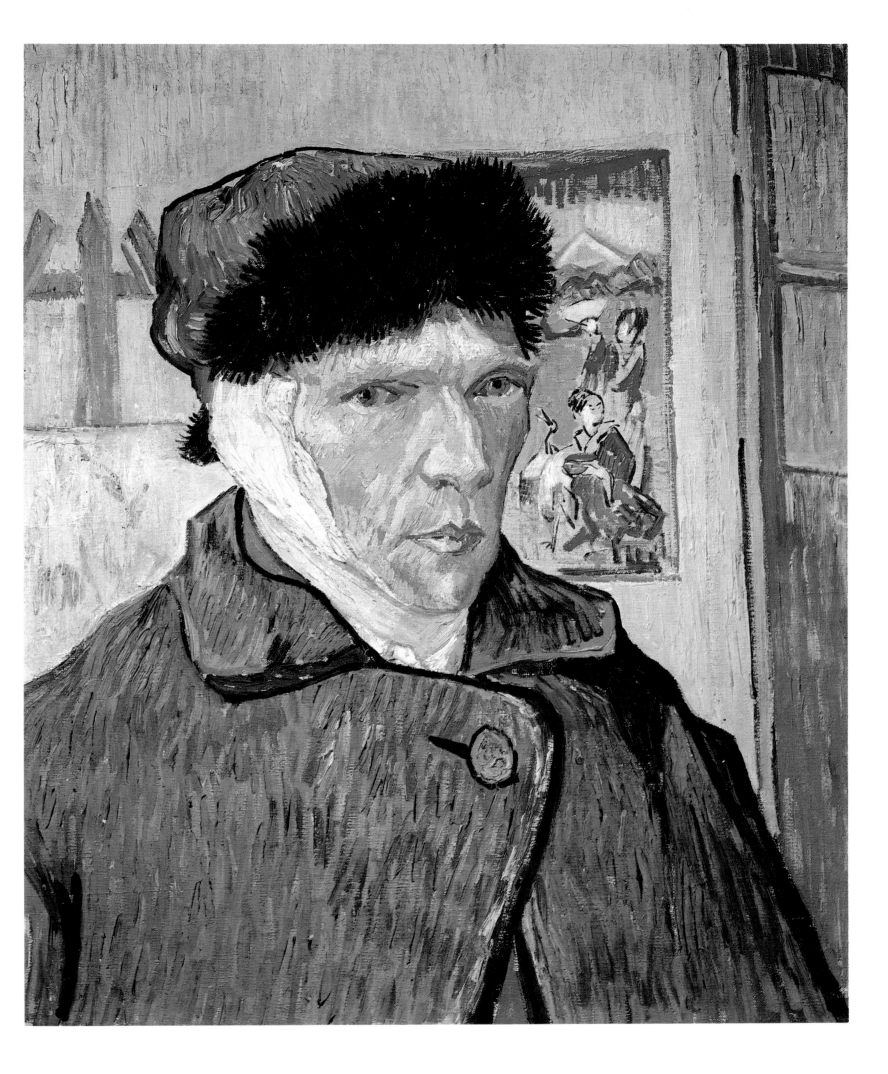

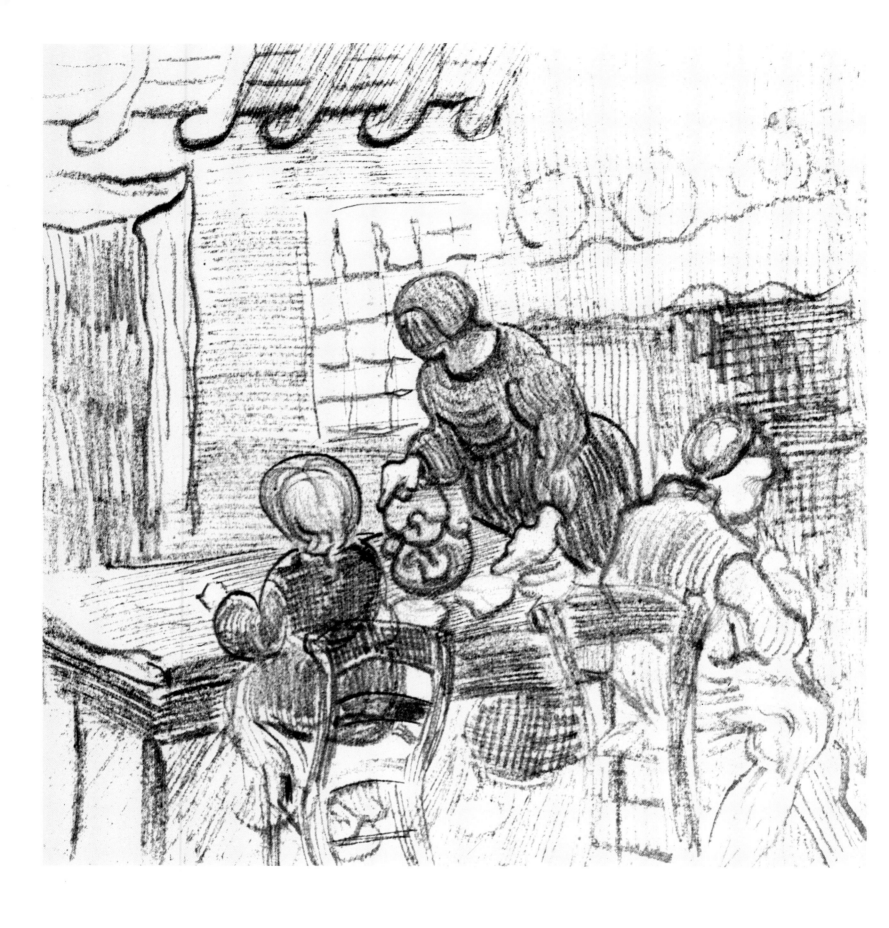

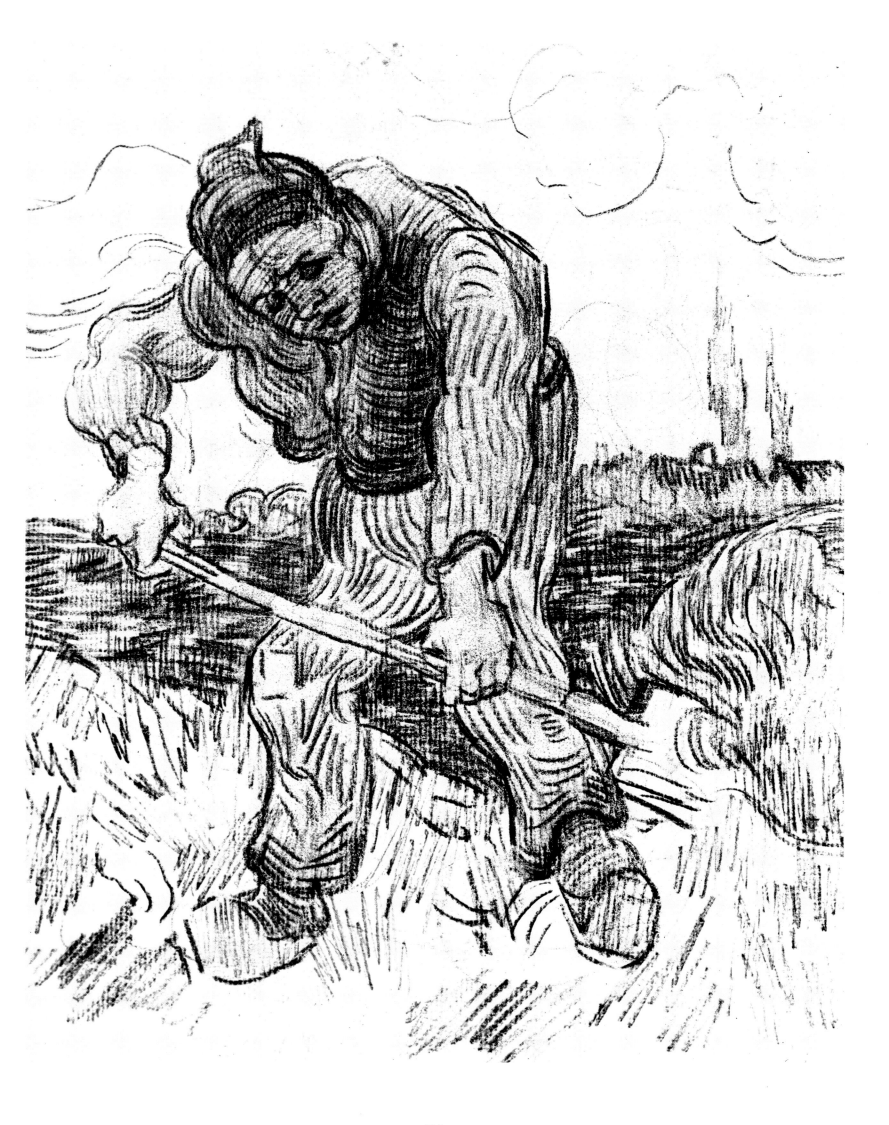

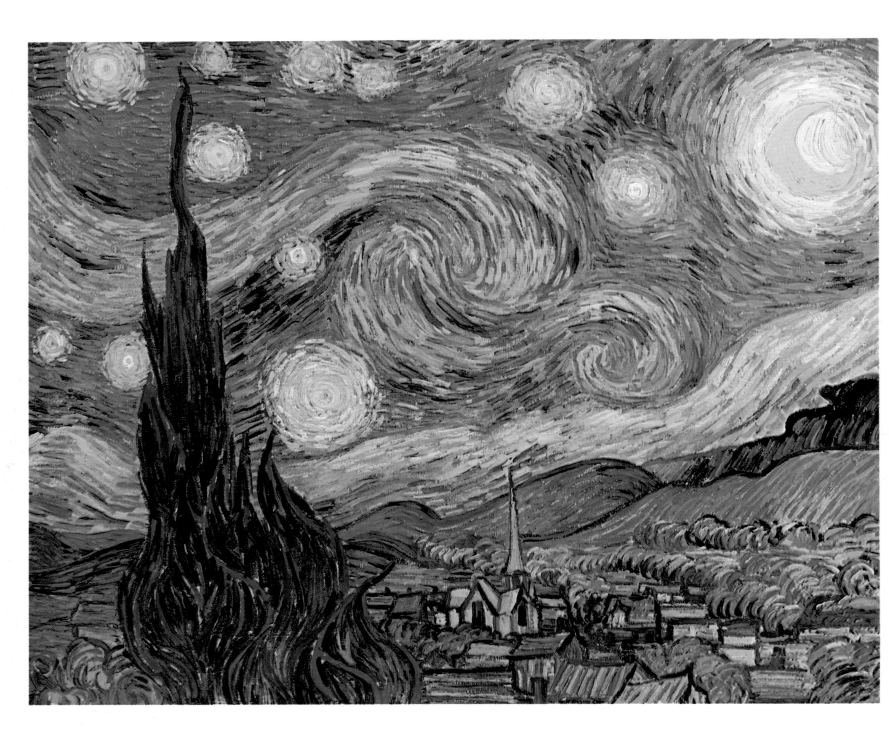

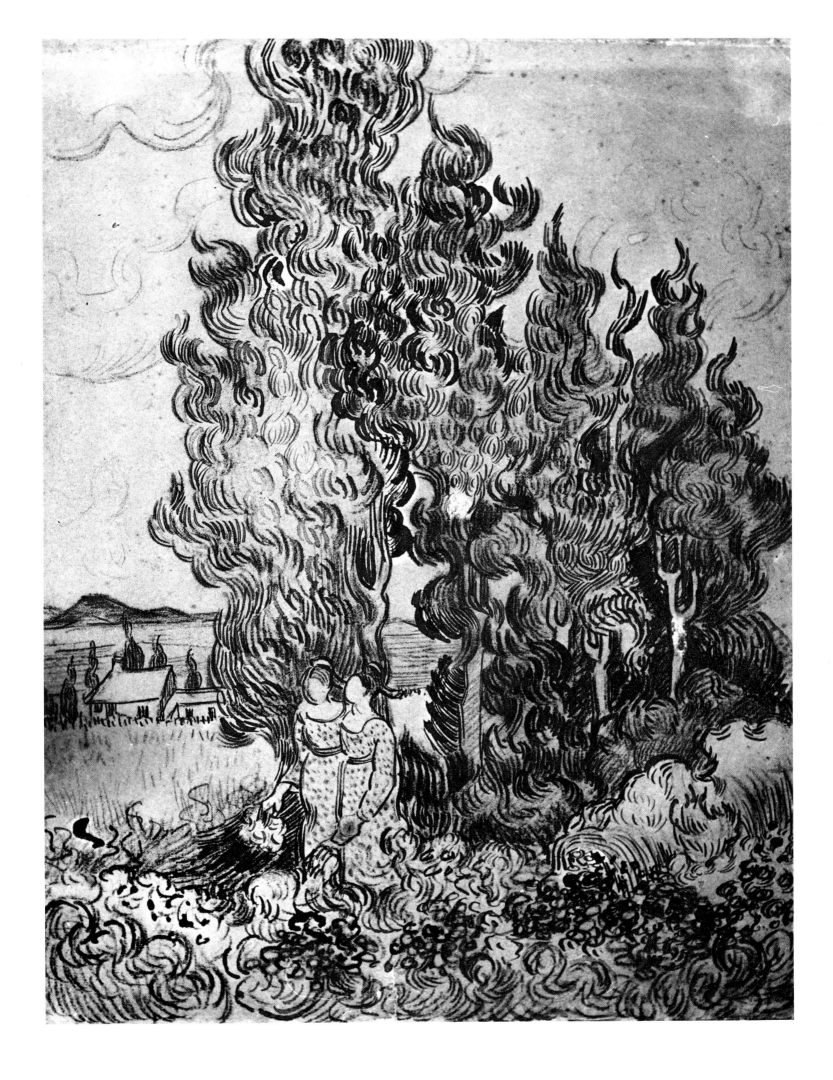

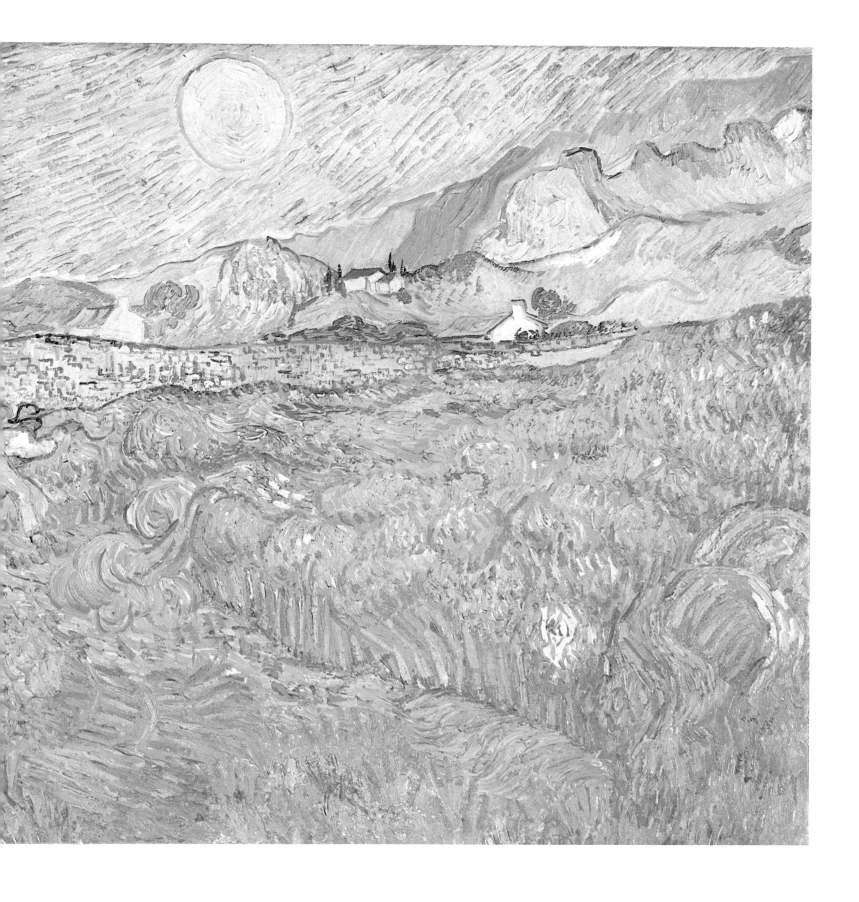

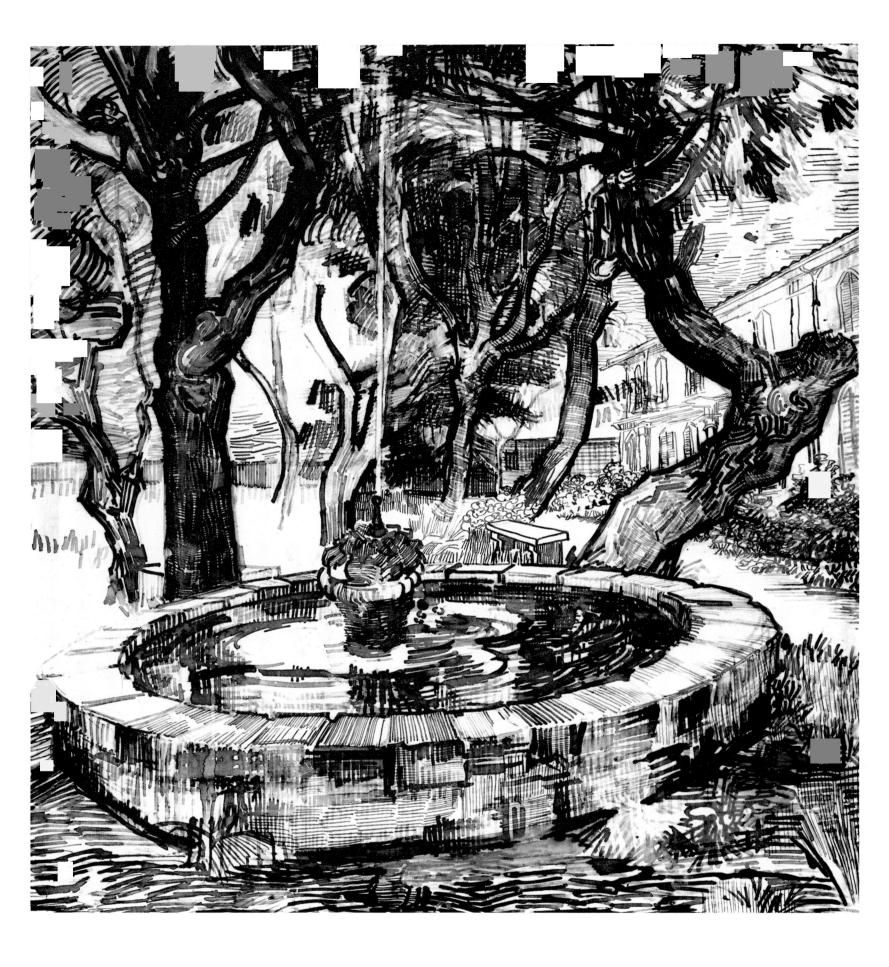

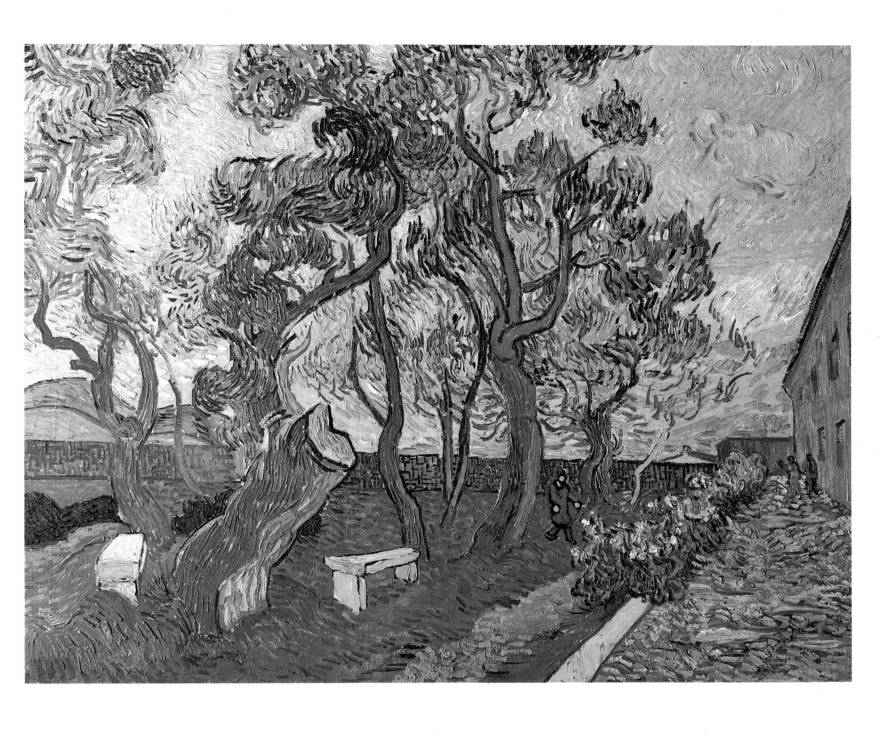

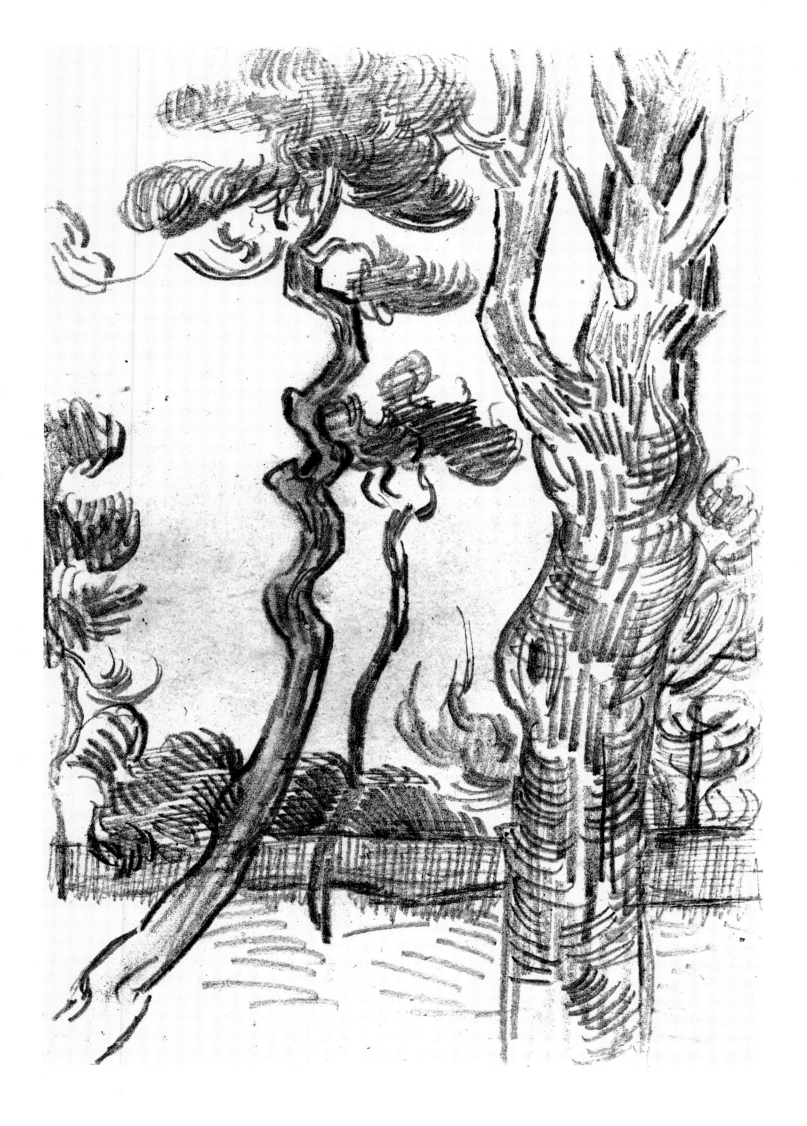

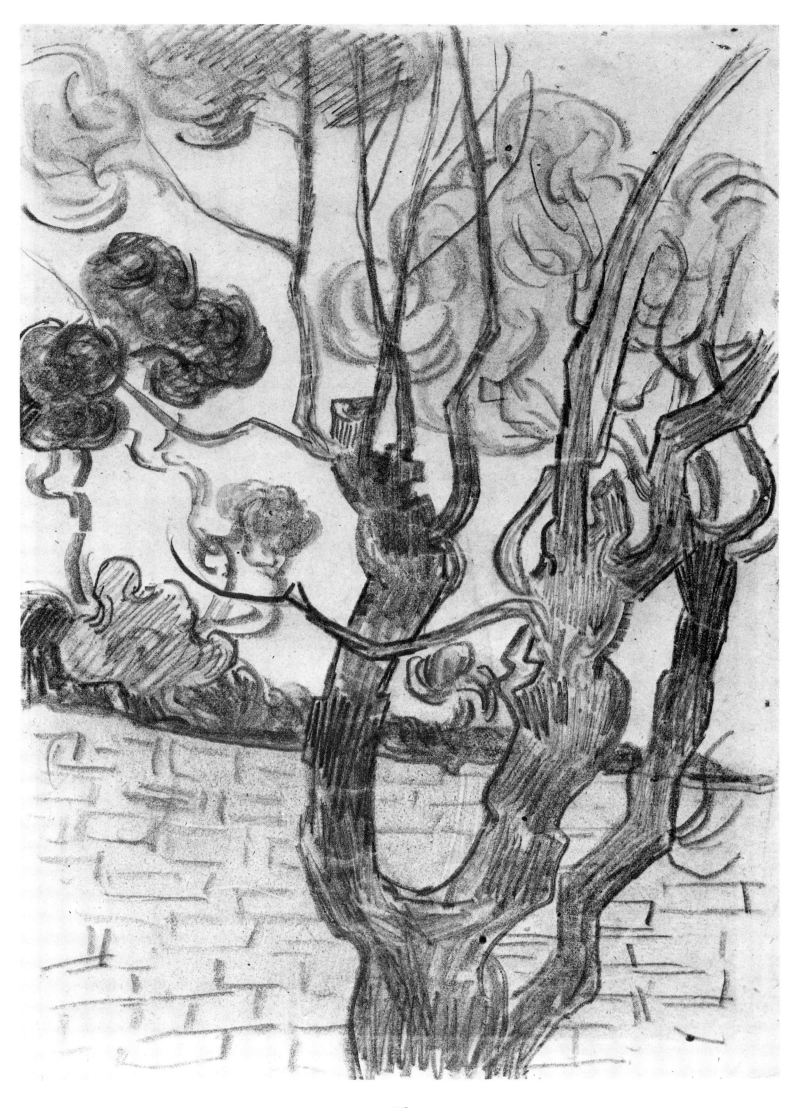

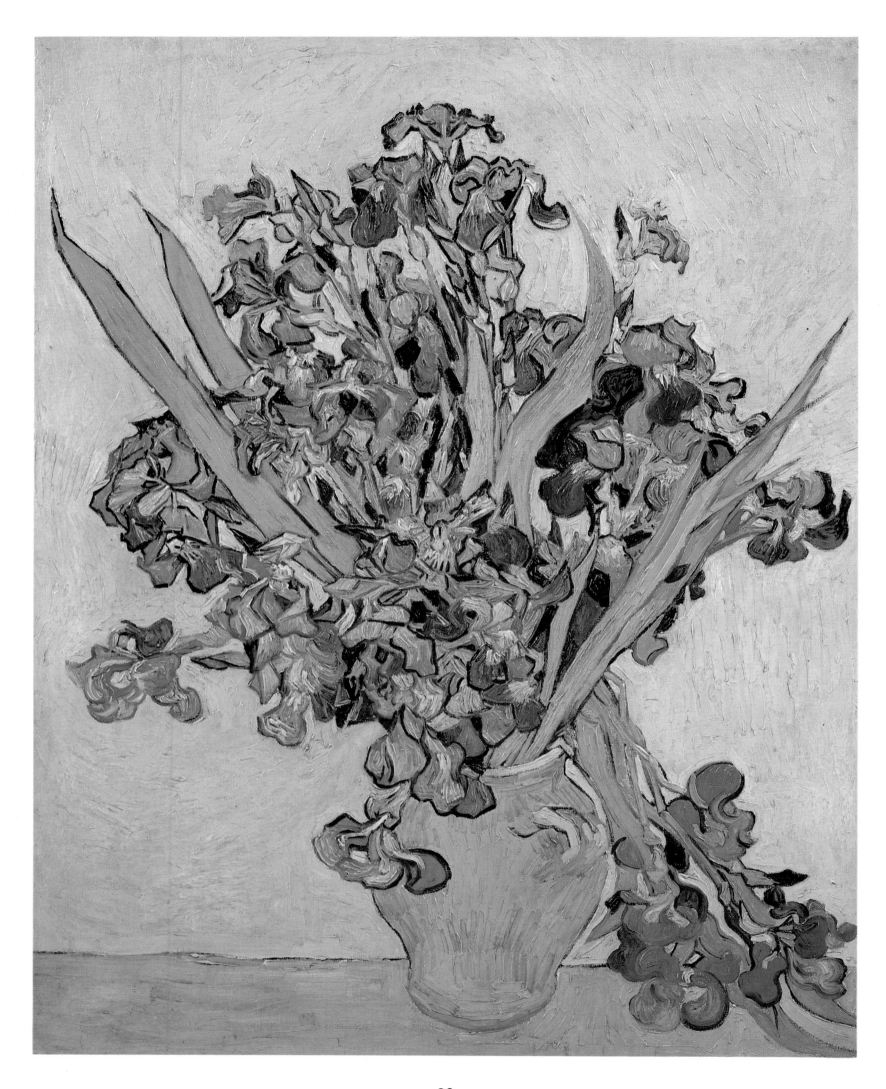

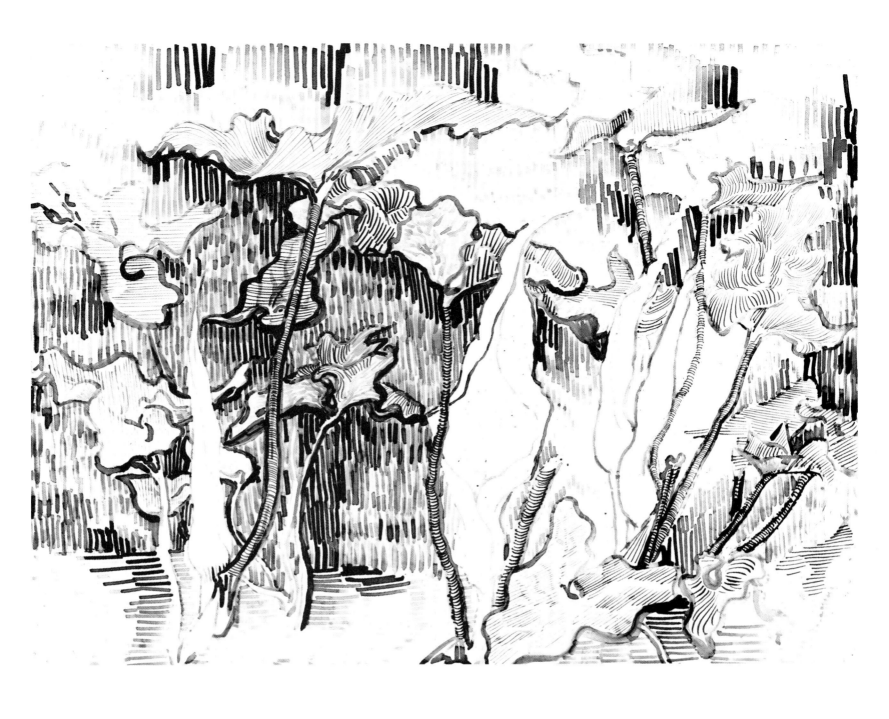

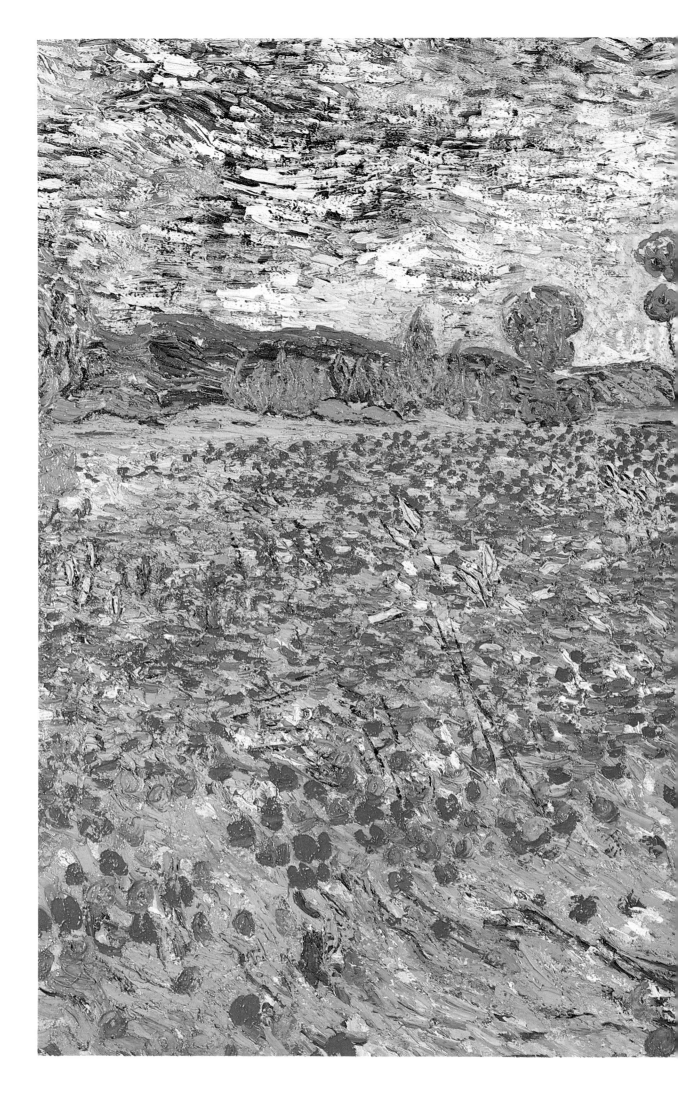

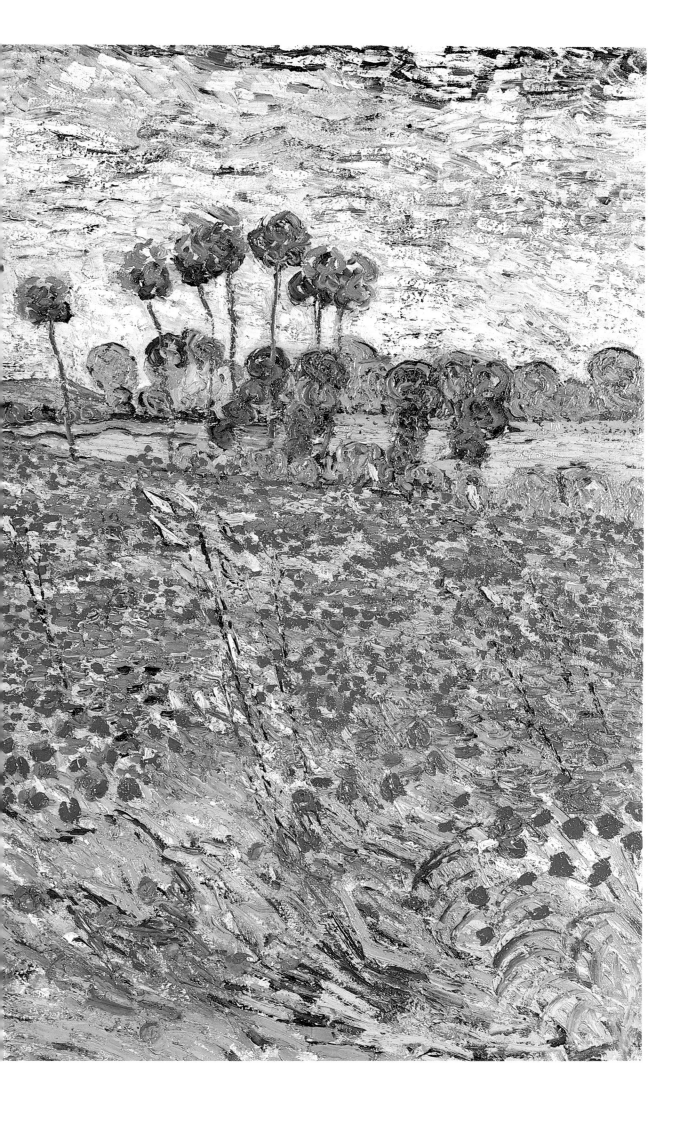

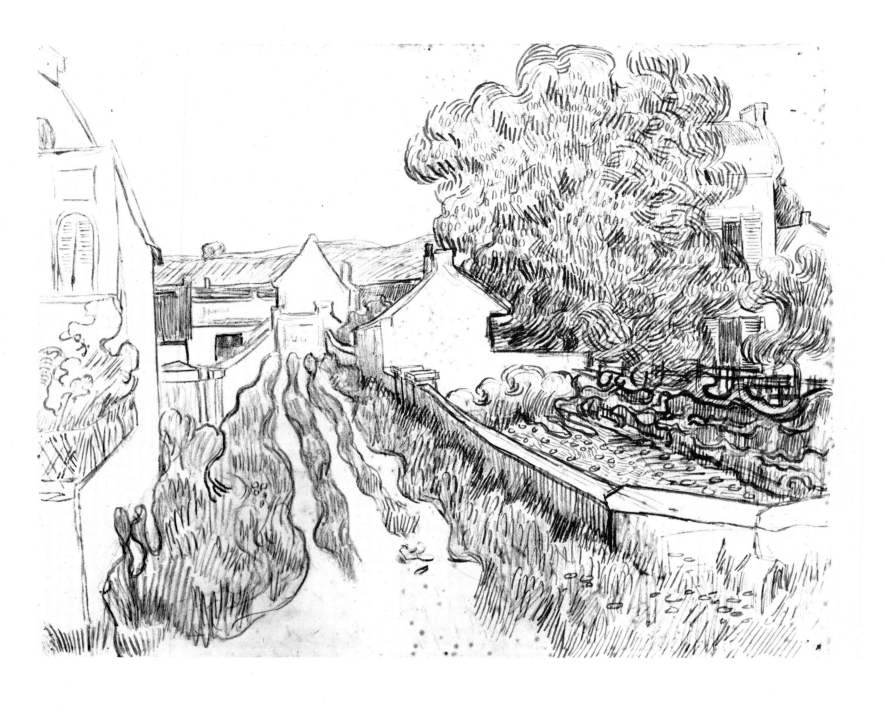

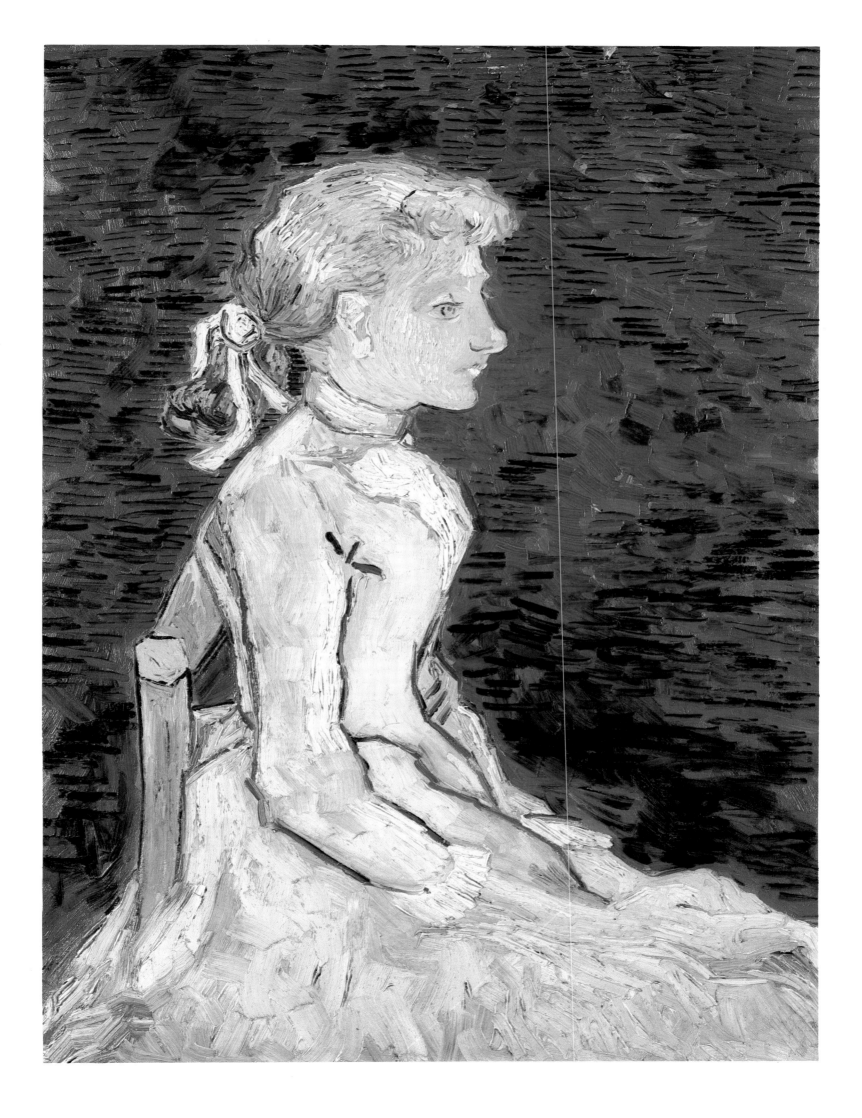

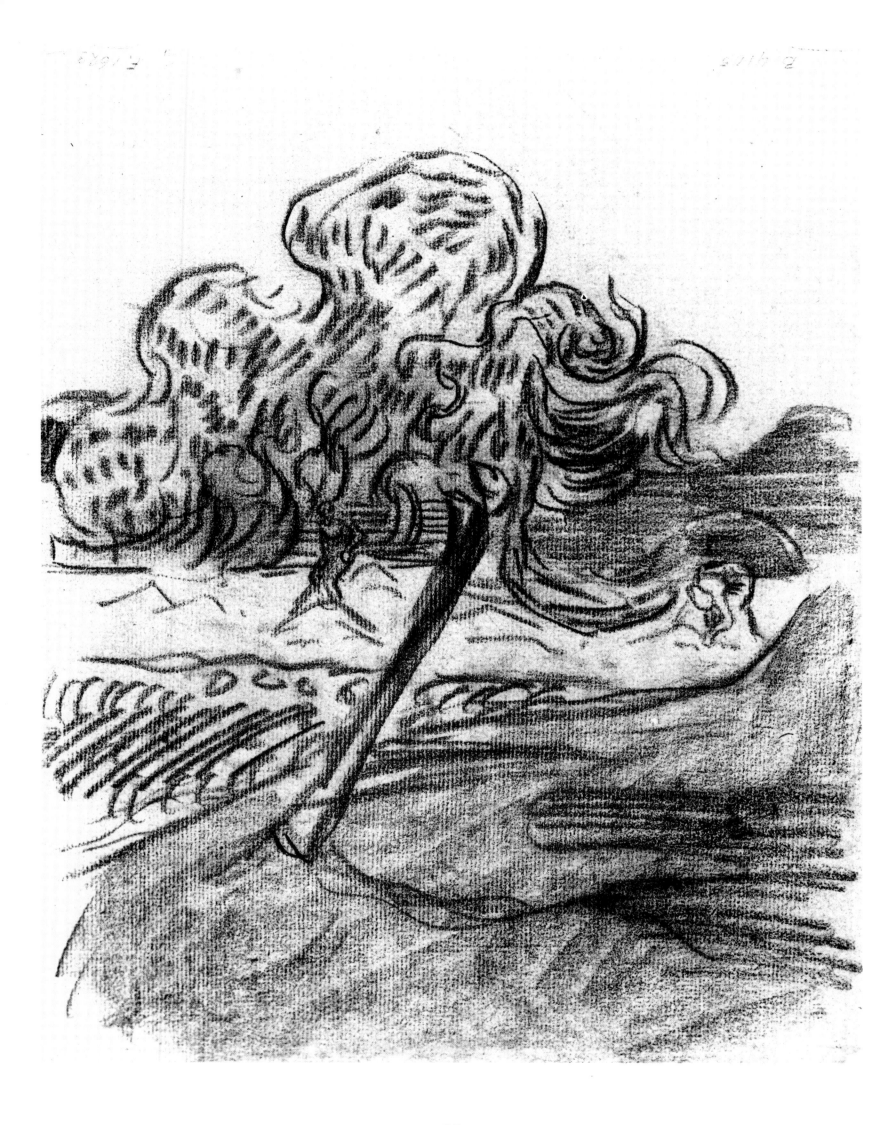

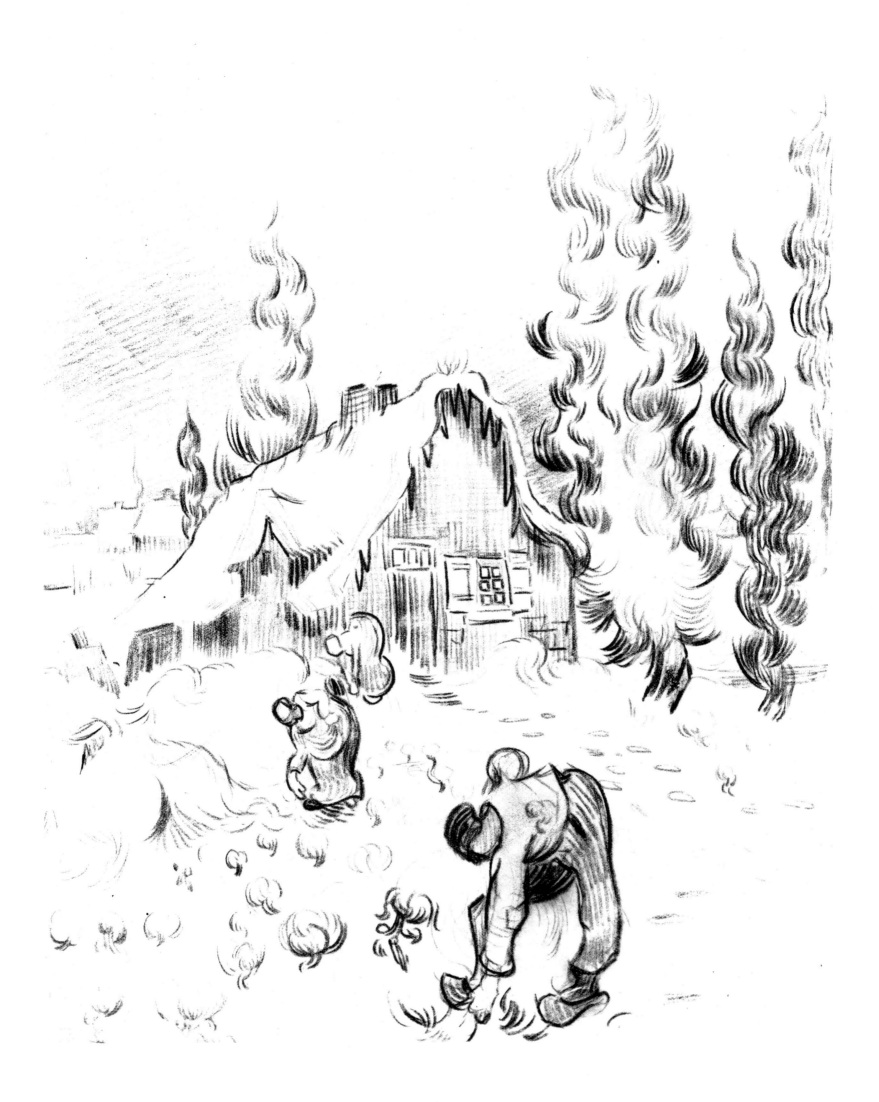

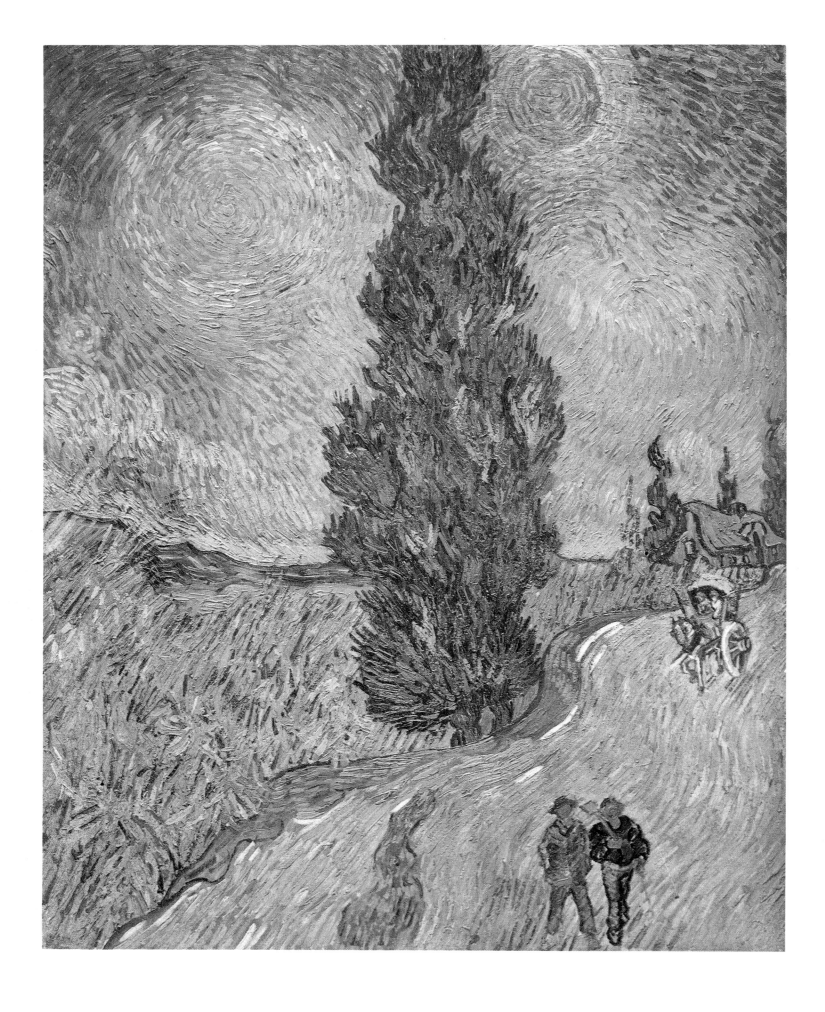

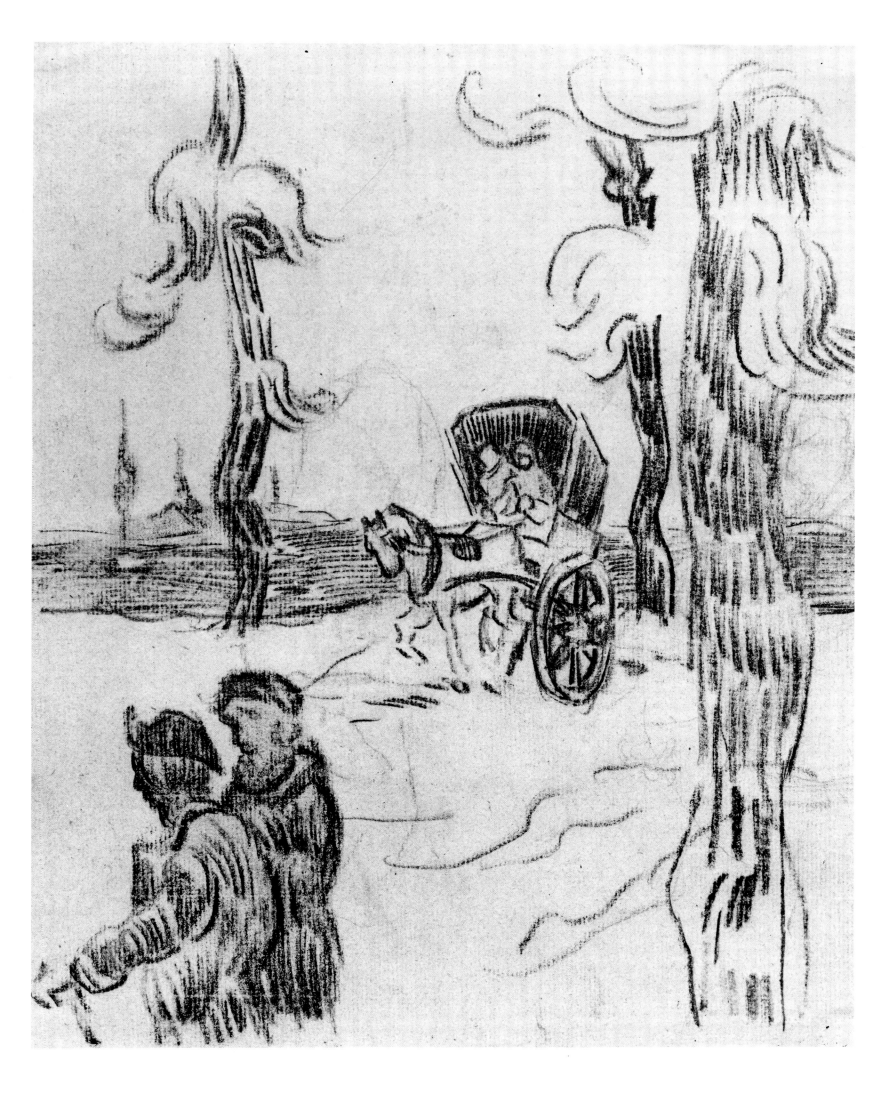

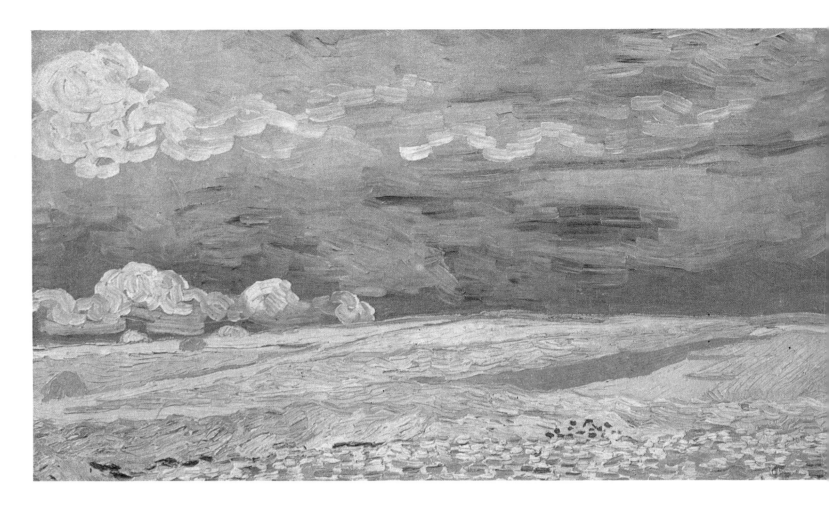

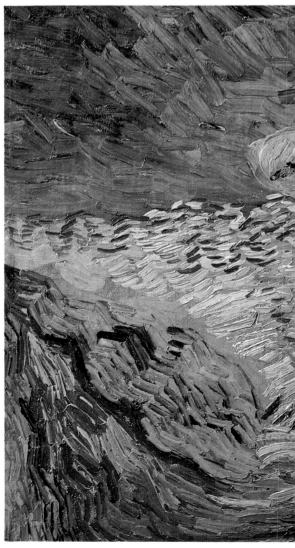

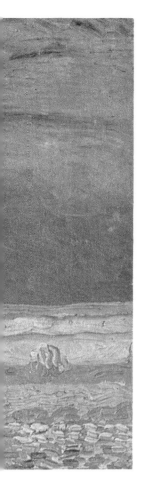

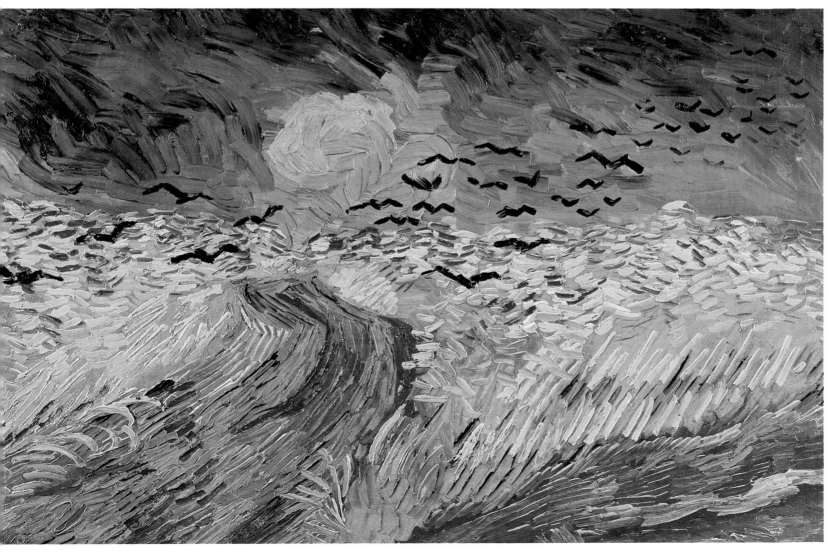

CHRONOLOGY

1853–1879 Birth and Early Years

Vincent was born on March 30th 1853 in Groot Zundert in Brabant. His father was a pastor and came from an influential Dutch family. As a boy, Vincent received an ordinary school education, and in 1869 he began an apprenticeship as an art dealer in the famous Goupil gallery in The Hague, a branch of their firm in Paris. In 1873 his younger brother Theo embarked on the same career, though at the Brussels branch; that same year Vincent was moved to the firm's London agency, and finally in 1874 to their house in Paris. But he had strong religious tendencies, and neglected his chosen profession: his skimped duties culminated in his dismissal. In 1876 he returned to England; at first he accepted a position as an assistant teacher in Ramsgate, but soon moved to Isleworth and became an assistant preacher there. At the end of the year, he returned home to his parents, a physical and nervous wreck; his father had meanwhile been moved to a living in Etten. After a brief interlude in a bookshop, Vincent sat the entrance examination for a theology degree in Amsterdam, but failed; and he was also rejected, after a short trial period, by a mission school in Brussels. In desparation, Vincent went to the Belgian coal-mining district of the Borinage as a missionary; here he struggled to work for six months in the most miserable circumstances. The same year saw Theo reach the first milestone in his career as an art-dealer: he became director of the Parisian branch of the Goupil gallery.

1880–1885 Holland · The Beginnings of Artistic Activity

At the age of 27, Vincent was suddenly and spontaneously overcome by an urge for artistic activity. He devoted himself to art with the same passion he had expended on his religious and missionary projects. Unwilling to compromise, he was unable to understand that his family, disillusioned by the downfall of all his previous ambitions, had no confidence in this new passion. He abandoned his studies in Brussels and a course of training with his uncle Anton Mauve, a painter of some distinction. At the end of 1881, he quarrelled with his father. In 1882, he was living with a woman; in an attempt to rescue her from the shipwreck of life, he had taken her in, but he, no less than her, fell victim to its rough seas. In 1883 he and Sien, as he called her, separated in dramatic circumstances, and Vincent moved back to the inhospitable countryside in the northern province of Drenthe; here he ruined what remained of his health while attaining for the first time a measure of artistic maturity. But his illness forced him to return. In his parents' house in Nuenen, with a separate studio, Vincent made a sustained effort to imbue his art with his own

personality. The zenith, the keystone of this formative phase was to be the painting known as *The Potato-eaters.*

1886 The Move to Paris

In January, Vincent embarked on a course at the Antwerp Academy, but this move soon proved a mistake. He could not and would not adapt to their antiquated system; he could not waste his time with plaster models. Further, his achievements so far bore little relation to what the profession was looking for, and it was only March when his time at the Academy came to an abrupt end. Vincent turned instead to Paris: he was convinced that here alone lay the road to success. He sought lodging with his brother Theo, somewhat to the latter's surprise.

For three months Vincent worked in the Cormon studio, where a stream of Impressionist painters were already learning their art. Here he met Emile Bernard and Toulouse-Lautrec.

In June the van Gogh brothers moved house, and Vincent had a small studio at his disposal. He soon submitted to the Impressionist spell; he gazed at their paintings, discovered their techniques and above all their colours, and incorporated them into his own work. His colours became bright and warm, and with every picture light had a bigger part to play. He eschewed all the heaviness of his northern homelands: a new artist was born.

In November he made the acquaintance of the painter Gauguin.

1887 Paris · The Year of Maturity

Vincent van Gogh struck up close relationships with younger colleagues: Seurat and Signac exerted a powerful influence on him, and the result was a stream of pictures in which he experimented with the ideas of pointillism. He exhibited in the Café Tambourin, along with Bernard, Anquetin, Gauguin and Toulouse-Lautrec. He and Bernard painted together in Asnières, a country suburb of Paris. His painting acquired a new confidence and he produced the chefs-d'œuvre of his Impressionist period. He had attained the first of the high points in his life.

1888 Arles · A Time of Dramatic Development

In Paris, van Gogh's position now became untenable. Constant discussion with artist friends, hectic city life, and heavy nightly drinking

bouts took their toll on his health. He felt he could not continue so; he yearned for Japan, a Japan divorced from reality, a dream born of his study of Japanese coloured woodcuts. Toulouse-Lautrec, who knew the South, reccommended Provence, where light and atmosphere were as luminous as in Japan, and the people simple and cheerful.

Vincent moved to Arles; at first he was disappointed, arriving as he did in February to be greeted by a chilly landscape. But in March, when the orchards came into blossom, he was transported: their beauty seemed Japanese to him, and he was seized by a great rush of creativity. He felt better in himself, but worked feverishly, making pitiless demands on his exhausted body and living constantly on the verge of collapse. Recovery was out of the question.

In May he rented the *yellow house* but was not able to move in until September. He had dreams of emulating Parisian colleagues and founding a circle in the South. Paul Gauguin seemed the ideal leader and Vincent went to considerable trouble to bring him to Arles.

His hopes for good relations with the local people proved vain; they had little sympathy for Vincent, the unkempt, seemingly highly-strung painter from the far-off city, who roamed around like a tramp and filled canvas after canvas with incomprehensible explosions of colour, plastering paint on with an orgiastic fervour. When he wasn't painting, he was drinking; he slept in the mornings and evenings so as to paint in the fields under the blistering noonday sun, when the locals retired for their siesta. During the night he would paint by candle-light, trying to trace the secrets of the starry southern sky. Such a life-style seemed strange to the good citizens, and Vincent's original hopes of enjoying good relationships with the simple Southerners were quickly dashed. Only a few became close to him, and they were often moved primarily by sympathy for his spiritual suffering.

At this time, Gauguin was staying with Emile Bernard in Pont Aven, where they were working to develop cloisonism. This culminated in the formation of the Nabis group in Paris at the beginning of October. Formally speaking, Gauguin had little in common with van Gogh at this period, and it remains a mystery that he yielded to Vincent's urgings and agreed to work together with him in Arles.

On October 20th Gauguin finally reached Arles; van Gogh painted a few pictures using the new technique of cloisonism, although this was a passing phase. Collaboration with Gauguin was not without its problems, for both artists were too individual to adapt easily. On December 23rd. things finally erupted in a quarrel more terrible than usual, as a result of which Vincent cut off part of his ear; Gauguin

departed, or rather fled, leaving his friend in a state of severe psychological collapse. For Vincent, the year of sun-drenched depictions of Provence had ended in catastrophe.

1889 St. Rémy · Deepening Despair

Although Vincent was able to leave hospital in January 1889 for a short while, his condition was so unstable that he had to return in the spring. Finally, in March, his neighbours insisted on his committal to the asylum on the grounds that they considered him dangerous.

The first friend to visit was Paul Signac, who found him improved and not unhappy. Signac also visited his studio in the 'yellow house' and declared himself overcome by the brilliant colours in the pictures assembled there.

In April his brother and confidant married. The shock brought about a renewed attack: secretly, Vincent was afraid of losing his brother to these new family ties. With his brother's support, however, Vincent was fit enough by May to move to the asylum in Saint Rémy, where he was at least allowed a room of his own with a studio. Yet by the end of the year, he was already suffering renewed severe attacks, which confirmed the suspicion that he was no longer capable of living alone and unsupervised.

1890 Auvers · The Year of his Death

The eighth exhibition of *Les Vingts* included a number of van Gogh's paintings. As a result of this exhibition, they received a less than laudatory review from Henry de Groux. Henry de Toulouse-Lautrec, however, sprang to his defence with a vehement repudiation, and Albert Aurier wrote an enthusiastic article about van Gogh in the magazine *Mercure de France*.

Vincent and his brother both feared that a prolonged stay in a lunatic asylum would lead to a deterioration in his condition, for the inmates, some of whom were seriously deranged, had a deeply depressing effect on the artist. The art collector and doctor Dr. Gachet offered Vincent accommodation and care at Auvers, where he lived. Accordingly, he left his home in the South and moved to Auvers via Paris, where he spent a few days with his brother and sister-in-law. At first he put up at the Hotel Saint Aubin, moving later to a tiny room in the Café Ravoux. His proximity to Paris meant easier visits, and thus Theo was able to visit him in June and he himself spent a short while in Paris in July, when he arranged

a meeting with Lautrec and Albert Aurier. On his return to Auvers, he produced his last paintings: *Field with stormy sky* and *Wheatfield with crows.*

On July 27th Vincent van Gogh shot himself in the head with a revolver, probably during an attack. He was taken home and his brother hastened to his side. He died on July 29th. His funeral, on the 30th., was attended by Theo van Gogh, Camille Pissarro, Emile Bernard, his close friend Père Tanguy from Paris, who had supplied his paints, and Dr. Gachet. His faithful brother, whose own life had been so closely intertwined with Vincent's and who had constantly striven to clear every obstacle from his path, only survived him by a year. He died a victim to mental derangement.

The same year saw the first large-scale exhibition of Vincent van Gogh's paintings in the Salon of the Indépendants.

LIST OF ILLUSTRATIONS

Seated peasant woman with white cap. 1884 25
Drawing. Pencil and pen, 32 x 20.5 cm
Vincent van Gogh bequest,
Rijksmuseum Vincent van Gogh, Amsterdam

Seated girl. 1883 26
Drawing. Pencil and pen, 50.5 x 31 cm
Vincent van Gogh bequest,
Rijksmuseum Vincent van Gogh, Amsterdam

Weaver. 1884 27
Oil on canvas, 70 x 85 cm
Rijksmuseum Kröller-Müller, Otterlo

Sien with head on hand. 1882 28
Drawing. Pencil and pen, 58 x 42 cm
Rijksmuseum Kröller-Müller, Otterlo

Still life. About 1886 29
Oil on canvas, 41 x 38 cm
Von der Heydt-Museum, Wuppertal

Stormy weather. 1885 30
Pencil drawing, 29 x 22.5 cm
Vincent van Gogh bequest,
Rijksmuseum Vincent van Gogh, Amsterdam

Reaper. 1885 31
Charcoal drawing, 44 x 34 cm
Vincent van Gogh bequest,
Rijksmuseum Vincent van Gogh, Amsterdam

Vase with gladioli and white stocks. 1886 32
Oil on canvas, 65.6 x 35 cm
Museum Boymans van Beuningen, Rotterdam

The owl. 1886 33
Drawing. Pencil and pen, 35.5 x 26 cm
Vincent van Gogh bequest,
Rijksmuseum Vincent van Gogh, Amsterdam

Landscape with railway wagons, telegraph pole, and crane. 1888 54
Reed pen and pencil drawing, 24 x 32 cm
Vincent van Gogh bequest,
Rijksmuseum Vincent van Gogh, Amsterdam

The Crau plain. 1888 55
Pen and pencil drawing, 48 x 60 cm
Vincent van Gogh bequest,
Rijksmuseum Vincent van Gogh, Amsterdam

Portrait of Armand Roulin. 1888 56
Oil on canvas, 65 x 54 cm
Folkwang Museum, Essen

Pool in a public garden. 1888 57
Reed pen drawing, 32 x 50 cm
Vincent van Gogh bequest,
Rijksmuseum Vincent van Gogh, Amsterdam

Entrance to the public gardens at Arles. 1888 58/59
Oil on canvas, 72.5 x 91 cm
National Gallery of Art, Washington

Sheet of studies with seven hands. 1886–88 60
Black chalk drawing, 32 x 24 cm
Vincent van Gogh bequest,
Rijksmuseum Vincent van Gogh, Amsterdam

The yellow house in the Place Lamartine. 1888 61
Oil on canvas, 76 x 94 cm
Vincent van Gogh bequest,
Rijksmuseum Vincent van Gogh, Amsterdam

Beach at Saintes-Maries. 1888 62
Reed pen drawing, 30.5 x 47 cm
Vincent van Gogh bequest,
Rijksmuseum Vincent van Gogh, Amsterdam

Cypresses. 1889
Reed pen drawing, 31 x 23 cm
Rijksmuseum Kröller-Müller, Otterlo

73

Sheaf binder. 1889
Oil on canvas, 44 x 32.5 cm
Vincent van Gogh bequest,
Rijksmuseum Vincent van Gogh, Amsterdam

74

The harvest. 1889
Oil on canvas, 59.5 x 72.5 cm
Museum Folkwang, Essen

75

Fountain in the garden of the Asylum. 1889
Reed pen drawing, 49.5 x 46 cm
Vincent van Gogh bequest,
Rijksmuseum Vincent van Gogh, Amsterdam

76

Asylum garden at Saint Rémy. 1889
Oil on canvas, 73.1 x 92.6 cm
Museum Folkwang, Essen

77

Two stone pines. 1889/90
Pencil drawing, 30 x 20.5 cm
Vincent van Gogh bequest,
Rijksmuseum Vincent van Gogh, Amsterdam

78

Tree in front of a wall. 1889
Pencil and charcoal drawing, 30 x 20.5 cm
Rijksmuseum Kröller-Müller, Otterlo

79

Still-life with Irises. 1890
Oil on canvas, 92 x 73.5 cm
Vincent van Gogh bequest,
Rijksmuseum Vincent van Gogh, Amsterdam

80

Study of plants with Aaron's Rod. 1890
Reed pen drawing, 31 x 41 cm
Vincent van Gogh bequest,
Rijksmuseum Vincent van Gogh, Amsterdam

81

Field with poppies. 1890
Oil on canvas, 73 x 91.5 cm
Haags Gemeentemuseum, The Hague

82/83